VAN GOGH

ON
LOCATION

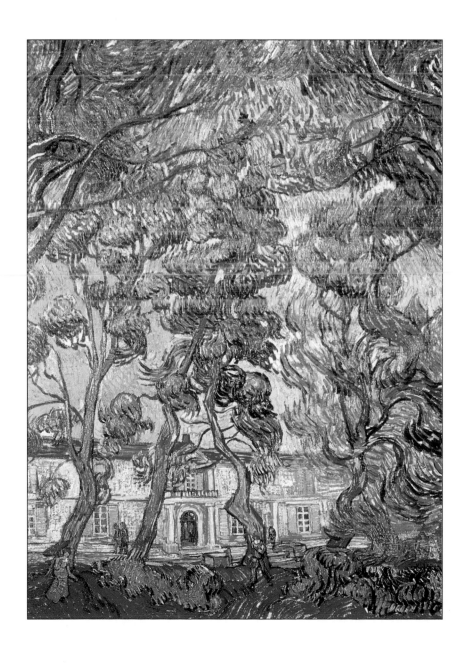

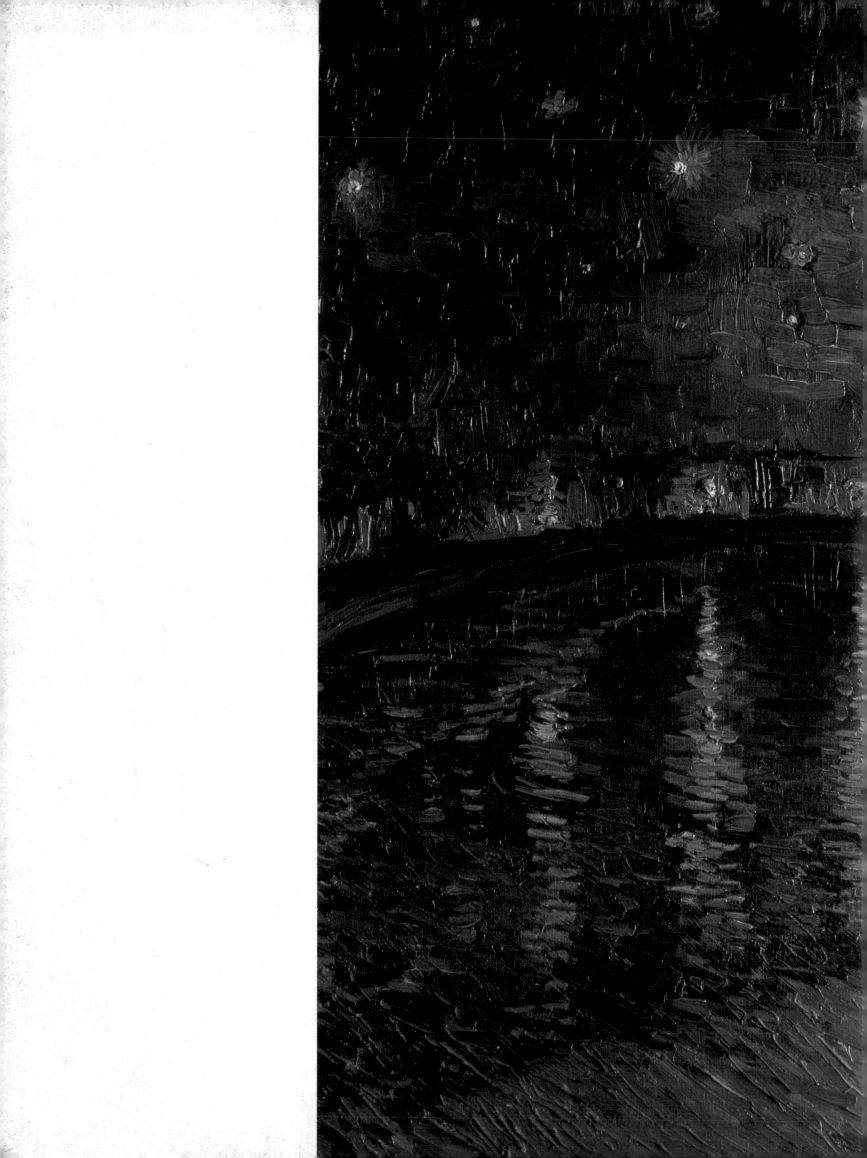

VAN GOGH
ON
LOCATION

Denis Thomas

CHARTWELL
BOOKS, INC.

Published by
Chartwell Books, Inc.
A Division of Book Sales, Inc.
Raritan Center
114 Northfield Avenue
Edison, NJ 08818
USA

Copyright © 1994 Regency House Publishing Limited

Published 1994

ISBN 0-7858-0107-3

Printed in Italy

Picture acknowledgements

The Publishers would like to express their gratitude to the museums, galleries and collections who have given permission to reproduce their paintings.

The Art Institute of Chicago: 45 right; Barbour Institute of Fine Arts, University of Brimingham: 28 bottom; Bayerische Staatsgemäldesammlungen, Neue Pinakothek, Munich: 73 bottom; The Bridgeman Art LIbrary: 1, 2-3, 4-5, 7, 11, 14 bottom, 18, 22-23, 29, 36-37, 39, 48 right, 52, 53 top, 53 bottom, 54, 61, 64, 66-67, 67, 68-69, 69, 72, 77 bottom, 78; The Bridgestone Museum of Art, Tokyo: 9; Collection Alfred Wyler, New York: 28 top; Collection Basil P. and Elise Goulandris, Lausanne: 35, 50; Collection L. Jäggli - Hahnloser, Winterthur: 8; Collection R.W. van Hoey Smith, Rockanje, The Netherlands: 25; Courtauld Institute, London: 56-57; Foundation Collection E.G. Bührle, Zurich: 10, top; Garman-Ryan Collection, Walsall: 21 left; Glasgow Art Gallery and Museum, Glasgow: 38 left; Kunsthaus, Zurich: 60 top; The Louvre, Paris: 71; Musée d'Orsay, Paris: 40-41, 46, 70 top; Musée Rodin, Paris: 49; Museum Boymans-van Beuningen: 26; Museum of Fine Arts, Boston: 75; National Gallery, London: 65 left; Network Photographers, London: 10 bottom, 48 left, 51 bottom, 60 bottom, 70 bottom, 73 top, 79; Private Collections: 51 top, 74; Rijksmusuem Kröller-Müller, Otterlo: 14 top, 15 top, 27, 33, 58, 76; Rijksmuseum Vincent van Gogh, Amsterdam: 15 bottom, 16, 17, 19, 24, 31, 32, 34, 38 top right, 38 bottom, 42-43, 44, 47, 55, 59, 65 right, 77 top; Stedelijk Museum, Amsterdam: 21-22, Yale University Art Gallery, bequest of Simon Carlton Clark, B.A 1903: 62-63.

Front Jacket:
Background: The Bridgeman Art Library, London.

Insert: Network Photographers, London.

Back Jacket: The Bridgeman Art Library, London.

The Publishers would like to thank Thames and Hudson for permission to quote from some of the letters between Theo and Vincent van Gogh.

The Publishers have made every effort to trace copyright holders of material reproduced within this book. If, however, they have inadvertently made any error they would be grateful for notification.

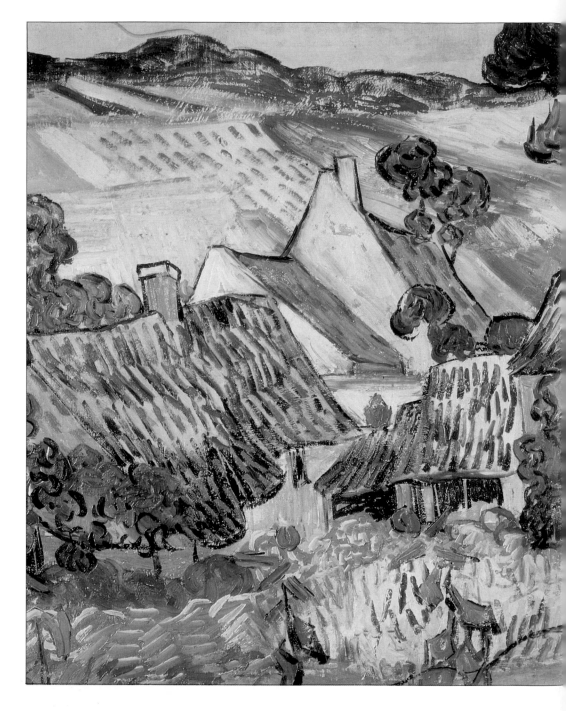

ABOVE
Thatched Cottages by a Hill,
Auvers-sur-Oise, 1890

TITLE PAGE
Trees in the Garden of
Saint-Paul Hospital, 1889

PREVIOUS PAGE
Starry Night over the Rhône, 1888

CONTENTS

HAGUE, LONDON........12

DORDRECHT, CUESMES........14

AMSTERDAM........16

THE HAGUE........20

DRENTHE24

NUENEN........ 26

ANTWERP........ 28

ANTWERP, PARIS.........30

PARIS........32

ARLES........42

SAINT-REMY........64

ARLES......... 66

SAINT-REMY........68

AUVERS........76

CHRONOLOGY

1871 Vincent's family leave Zundert at the end of January and move to Helvoirt, where his father has been appointed pastor.

1872 After spending his holidays with his parents, he pays a visit to his younger brother, Theo, at The Hague. The bonds between them, and their life-long exchange of letters, date from this time.

1873 Vincent is moved from The Hague to the firm's branch in Brussels, and then to Goupil's in London. Before leaving he makes his first visit to Paris and is deeply affected by the treasures of the Louvre. In London, lodging with a family called Loyer, he falls in love with their daughter, Ursula. Secretly engaged, she rebuffs him, plunging him into a crisis of yearning and despair. In November, his family arrange for him to be transferred to Goupil's branch at The Hague.

1874 After spending a few weeks at Helvoirt, his parents' new home, he sets off for London again, this time in the company of his sister Anna. He does not return to the Loyer family but finds lodgings elsewhere, plunges into religious texts and begins translating the Bible. Perhaps to relieve his disappointment in love, the family arrange to have him transferred to Goupil's in Paris. It seems not to have helped, and Vincent wanders back to London.

1875 After showing minimal interest at Goupil's and making himself unpopular with the staff, he intensifies his Bible studies, visits museums and art galleries, and discovers Corot and the classical Dutch painters of the 17th century. In October, his family move again following his father's posting to Etten, near Breda. Vincent, without permission from his employers, takes himself off to stay with them for Christmas.

1876 In April, Goupil's are taken over by another firm of dealers, Boussod and Valadon. Vincent, sensing that this might be the moment to leave, hands in his notice. His thoughts turn again to England. He applies for a residential teaching job there and is offered one as an assistant language master, unpaid but with free lodging. Before long, the proprietor moves his establishment to the London suburb of Isleworth. Seized by a new vocation, that of a preacher, Vincent decides to devote his life to serving the poor. Art, meanwhile, remains a side-line, though he becomes acquainted with Holbein, Rembrandt and the Renaissance masters at Hampton Court. Home again for Christmas he is urged by his parents, dismayed at his forlorn appearance, not to go back.

1877 His family, casting around for other possibilities, arrange a job for him in a book shop at Dordrect, with which there is some family connection.

Vincent takes his Bible translations with him, works on them busily, attends various churches, draws a little, and makes a friend of a fellow lodger who helps him to persuade his family that he should take up the religious life as a vocation. His father agrees that he should go to Amsterdam to prepare himself for the necessary examinations. Vincent makes the most of this opportunity to look at more paintings, resumes his practice of drawing, and teaches for a while at a Sunday school.

1878 He gives up his formal studies to spend three months at a college for lay preachers in Brussels, but fails the final examinations. Determined not to abandon his studies he makes for the Borinage, Belgium's coal-mining heartland. From a rented room between Mons and the French frontier, shared with a pedlar, he embarks on his first serious mission – bringing comfort and the Bible to the industrial peasantry. He shares their living conditions and reads to them from the Scriptures.

1879 Far from bringing commendation from the church authorities, Vincent's commitment to the miners and their families, including rescue work at pit accidents and an underground explosion, along with fervent support for a miners' strike, bring him nothing but blame. That summer he walks to Brussels to show the mission his drawings as evidence of the people's plight. He returns empty-handed, with no sanction to continue his work. Even Theo cannot find it in himself to support his brother in such a one-sided commitment.

1880 Dismissed and penniless, he makes his way on foot to Courrières, France, some 60 miles away. Jules Breton, a painter whom Vincent regards as highly as Millet, has lately built himself a new gallery there. Vincent, in his run-down condition, does not feel able to introduce himself and leaves. He makes contact with Theo, now working in Paris, who resumes his regular payments to support him. Describing his plight, Vincent says he is 'in a sort of mess' and suggests he is ready to mend his relations with the family. His own work revives as Theo's regular payments begin to arrive. He hastens to Brussels to gaze on paintings and to take a course in anatomy drawing at the Academy. He begins working in the studio of a new friend, Ridder van Rappart, who becomes a life-long companion.

1881 A meeting with Theo at Etten encourages him further. He falls in love for the second time, on this occasion with a recently widowed cousin, known as Kee, who is staying at the vicarage in Etten with her infant son. He attaches himself to them but finds that his attentions are unwelcome. Kee

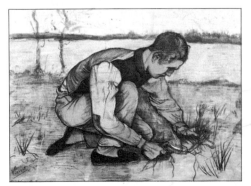

Weaver Facing Right, 1884

hastens back to Brussels and the disconsolate Vincent returns to The Hague. There he seeks the company of painters, among them Anton Mauve, a member of the family by marriage, who gives him a box of watercolours to experiment with.

Vincent seeks out Kee again, but she declines to see him. In a foreshadowing of what lays ahead for him, he holds his hand in a candle flame to prove his devotion, but to no avail. That autumn he accepts an invitation to paint with Mauve at The Hague, has a bitter argument with his strictly orthodox father, and leaves. In December, he spends a month studying under Anton Mauve at The Hague.

1882 His association with Mauve ends in acrimony. At this sensitive moment he invites a pregnant prostitute, Clasina Hoornik, whom he knows as 'Sien', and her two small children, to move in with him. This puts further strain on his relations with those close to him. He announces that he wishes to marry Sien, taking on the children as part of a ready-made family. He takes her to Leiden to have her baby and looks for larger lodgings for them all to move to. He resumes his interest in contemporary black-and-white illustration of the kind he first admired in London, with its images of social deprivation.

1883 It dawns on Vincent that family life of the kind he is engaged in is inappropriate for a professional painter such as himself. With genuine distress he dissolves the family group and looks for a totally different experience. His choice falls on Drenthe in northern Holland, a bleak industrial tract with nothing to divert him from a life of penance and privation. He reaches the marshlands, takes a barge to New Amsterdam, and embraces the bleak austerity of the peat-fields. After some months this environment gets the better of him. Lonely and homesick he makes his way back to Nuenen, the strictly religious community to which his parents have lately moved. He brings with him an armful of sketches, drawings and paintings, leaving many others behind.

1884 Vincent finds himself pleased to be under the family roof again. When his mother has a fall and breaks her leg, he attends her with devoted care. He paints the little Protestant church with a hedge and trees round it, and fixes up a make-shift studio in the sexton's house nearby. With the Sien episode behind him he attracts the attentions of a neighbour's daughter, Margot, ten years older than himself. They discuss marriage but neither family will agree. Margot, in her despair, takes poison – not fatally, but to the anguish of her disappointed suitor.

1885 On 26 March, much to his dismay, Vincent's father suddenly dies after a heart

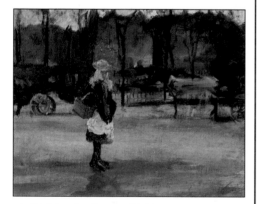

A Girl in the Street, 1882

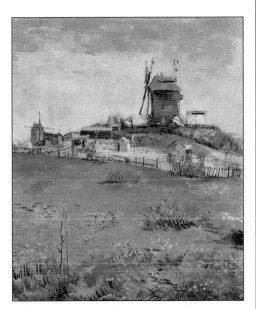

Le Moulin de la Galette, 1887

attack. Vincent consoles himself by producing a still life with a vase of honesty in company with his father's pipe and tobacco pouch. He turns his attention to *The Potato Eaters*, rated among the finest works of his Dutch period. In August, two of his paintings are exhibited in a paint-shop window at The Hague. He makes a visit to Amsterdam, which consolidates his devotion to Frans Hals and Rembrandt. He rents a room above a paint-shop, draws the Cathedral and market-place, lives on dry bread, paints the street-women, who demand payment, then registers as a pupil at the Academy, on the grounds that there, at least, he will be provided with models without charge. In the city's dockland area he comes across a quantity of Japanese woodcuts which are to hang in his rooms for the rest of his life.

1886 In poor health and depressed at his lack of progress, he decides that the only answer is to move to Paris. He scribbles a note to Theo, who now has a senior position in the firm of Boussod and Valadon, art dealers, suggesting that they set up home together. Instead, Theo offers him a room in his own apartment. Vincent enrols at a respected school, Cormon's, where he finds several like-minded spirits, among them Toulouse-Lautrec and Emile Bernard. He is introduced to Julien Tanguy's paint store, an informal art gallery for the avant-garde, where Vincent deposits some works of his own. He begins to feel that he is among sympathisers, including the well-regarded Gauguin, just back from Pont-Aven.

1887 His belated discovery of Paris produces a succession of works painted in a lighter pallette and of recognizably Impressionist subjects. He discusses Post-Impressionism with Gauguin and Bernard, and exhibits pictures in some of the artists' favourite haunts, such as Le Tambourin. He now regards himself as part of the bohemian scene, experimenting with Pointillism and making friends with its leading practitioners, Seurat and Signac. His fellow student, Toulouse-Lautrec, sketches his portrait at Cormon's Academy.

1888 His next destination is Arles, the small town in Provence where he has thoughts of establishing an artist's colony or co-operative on the lines of Gauguin's group at Pont-Aven. He plunges into a routine of painting every natural subject in sight, from trees in blossom to tender still lifes. News that Mauve has died gives him a pang of remorse. He inscribes a flower-study he has just finished to his memory and signs it 'Vincent' – the name that he always preferred. He attends a local bull-fight, pays attention to local goings-on and paints a series of stunningly expressive portraits. Crates of paintings

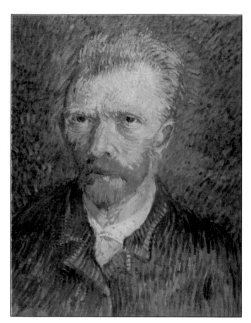

Self-Portrait, 1887/88

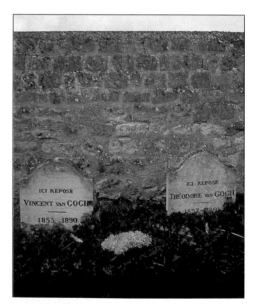

The graves of Vincent and Theo, side by side in the cemetery at Auvers

begin to be dispatched by rail to Theo in Paris. In June, he makes his first visit to the Mediterranean, Saintes-Maries-de-la-Mer, where he paints fishing boats drawn up on the beach and encounters an officer of the Zouaves, whose portrait he paints. Other portrait subjects quickly follow, among them the postman, Joséph Roulin, bearded, according to Vincent, 'like Socrates'. There follows the *Sunflower* series, painted to decorate his studio, in which he sees the sacred glow of a stained-glass window. In early autumn he paints *The Night Café in the Place Lamartine*, which he invests, he says, with 'terrible human passions'.

He now hears from Gauguin that he expects to arrive at Arles on 23rd October, and by November the two painters are discussing plans for their co-operative. Vincent accepts his friend's assumption that he, Gauguin, is to be the leader of the group. In Paris, meanwhile, Theo is successfully selling works by Gauguin. By December, there are signs that the partnership is becoming strained. Just before Christmas comes the tragic culmination when Vincent severs the lobe of his left ear after a quarrel, and offers it for safe keeping to one of the girls at the nearby brothel. Vincent is taken to hospital under the care of Doctor Félix Rey, the subject of one of his many portrait studies at this time. Theo hurries home to arrange for Vincent's treatment. After a few anxious

days he is pronounced 'recovered'. He admits that his friend Gauguin is 'a little out of sorts with Arles, the little yellow house where we have been working together, and especially with me.'

1889 Writing from hospital early in January, Vincent says he is better, sends greetings to Gauguin and says he will stay in hospital for a little longer. On 7 January, he is brought home to The Yellow House and writes reassuring letters to his mother and sister. A week later he paints his portrait of Doctor Rey and works in his studio. On 3 February he paints a further version of Madame Roulin, the postman's wife. Within the week he has a relapse and is taken back to hospital, where ten days later he is moved to a hospital cell. On 2 May he arranges for two crates of pictures to be sent to Theo. Of his own volition he is admitted to the mental hospital near Saint Rémy as a private patient and is given rooms overlooking the garden. In July he makes a visit to Arles, where he suffers a stroke. That autumn he makes copies of works by Millet and Delacroix and submits half-a-dozen works to an exhibition of contemporary painting in Brussels.

1890 His first exhibited works receive an enthusiastic review in a leading art journal. A son is born to Theo and his wife, whom they christen Vincent. A painting of his, *The

Red Vineyard, fetches 400 francs in a Brussels gallery. Ten works are shown at the Salon des Artistes et Indépendants in Paris. He visits Theo and family there, then moves to Auvers-sur-Oise, within easy reach, where Theo knows a doctor, Paul Gachet, who is himself a painter and well-known among younger artists. Vincent resumes painting, including the local church and a dramatic study of a cornfield with crows under a turbulent sky. On 27 July, he confesses to Gachet that he has shot himself. Gachet dresses his wound and sends for Theo. Two days later Vincent dies. Theo does not long survive him. The brothers lie side by side in the cemetery at Auvers.

Boats with Men Unloading Sand. Undated

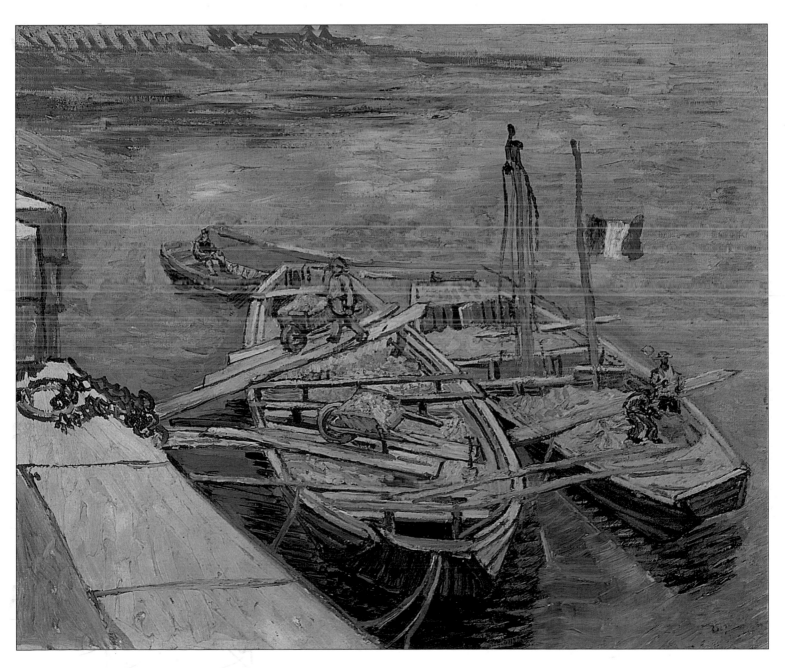

THE HAGUE TO LONDON: _____

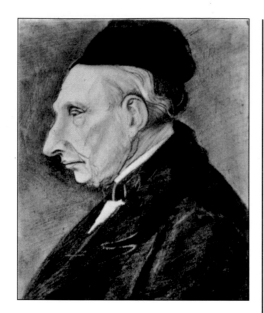

ABOVE
Vincent's father, a pastor of the Dutch Reformed Church in Brabant, southern Holland

BELOW
Vincent's picture-dealer brother, Theo, his lifelong champion and supporter

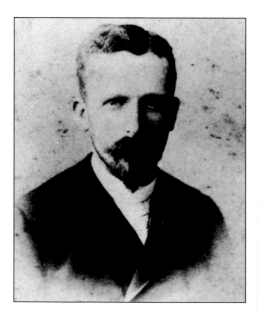

Vincent's early career took him to various branches of Goupil's including London, where a growing religious fervour soon led him to the Borinage and Drenthe.

One day in the middle of March 1886, a note from Vincent van Gogh was delivered to the Paris office of his picture-dealer brother, Theo, scrawled in black letters: 'Do not be cross with me,' it read, 'for having come to Paris so suddenly. I have been thinking about it a lot. I shall be in the Louvre from midday. Please let me know what time you can come and we'll fix things up.'

This was no sudden impulse on Vincent's part. Having suffered numerous disappointments in his attempts to launch himself as a painter in Holland, he was bracing himself for a new effort. Now, at the age of 33, his thoughts were firmly fixed on Paris, where he intended to enrol at one of the more distinguished schools, if they would accept him. He was anxious that his work might fall short of the required standard. On the other hand, he was prepared to smarten up his general appearance in order to make a good impression on the selection committee.

He was also anxious to produce some new paintings and persuade Theo to take a studio with him. What about a place that the two of them could share with a garret or corner of an attic in which to paint? He, Vincent, could sleep in the garret and Theo in the main studio. Theo, of course, would have to be responsible for paying the rent.

Vincent had toiled in industrial wastelands, trying to reconcile his concern for the poor and helpless with the urge to express himself as an artist. In the grim mining villages of the Borinage, in Belgium, he had allied himself with people who, but for the strength of their religious faith, would have found it even harder to survive. His early drawings of the period show a desperate sympathy with their plight.

He was no stranger to disappointment. Though he was still a young man when he finally arrived in Paris in pursuit of his ambitions, he had suffered cruelly along the way. His father, following family custom, was dedicated to the strict teachings of the Dutch Reformed Church. He was pastor of a parish in North Brabant in southern Holland, a God-fearing region where social values were based in deeply-rooted faith. He was well-respected locally, and extended his concern to the Catholic families who were the Van Goghs' neighbours.

Eleven months after Pastor van Gogh and his wife Anna were married, their first child was born, only to die in the process of delivery.

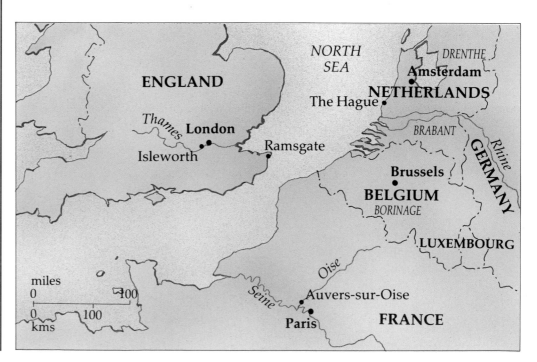

'keep yourself to yourself...'

They named him Vincent Willem. The stricken parents buried him in the little graveyard beside the church, with a plaque bearing his name. One year later to the day, on 30 March 1853, a second son was born. The parents gave him the very name that they had chosen for their first son. From his early childhood, therefore, the second Vincent was always aware of the strange coincidence surrounding his birth and could not escape from seeing his own name on his brother's grave as he passed it on his way to church. The implications of this experience and the possible effect on the young Vincent may have been significant.

He had been difficult and rebellious in childhood, an introvert, content with his own company. He was devoted to animals, birds and insects which he studied with endless fascination. By the age of eight, he was beginning to produce drawings of plants and animals encountered on his walks. He became a precocious naturalist, collecting specimens from his wanderings in the fields. He was enchanted with the natural world and would return home with pencil sketches of caterpillars, moths, chestnuts and periwinkles. When his parents decided it was time to take him away from the village school, they sent him as a boarder to the school at Zevenbergen, 19 miles away. He spent two years there – an ordinary boy, as people dimly remembered when Vincent's name became famous, whom at the time they had either disregarded or hardly noticed. His parents paid him the usual visits; and he later recalled how he used to stand on the school steps in order to catch the earliest possible glimpse of his mother and father as their carriage came into view.

Those who did remember him as a child recall that there was 'something strange' about him. A domestic help remembered that he had an awkward manner, was covered in freckles and continually invited punishment. A son of the family's gardener recalled that Vincent was clever with his hands and forever in the carpenter's shed. The Pastor, though undemonstrative where outward shows of affection were concerned, took pride in his son's talents. He was even moved to hang one of the boy's drawings, of a farm wagon, in the family drawing-room.

The solitary habits which isolated him from society were excused as the behaviour of a free spirit. His sister, Elisabeth, recalled that when she and the other children saw Vincent setting off on his own with a jar and fishing net, it would not even have occurred to them to ask if they could accompany him, so used were they to his solitary ways. They marvelled at the exotic insects he brought back with

An advertisement sets the young Vincent on the way to a brief career teaching in suburban London

him, and the way he would recite their Latin names as he neatly mounted them in paper-lined boxes.

When the time came for him to think about earning a living, the realistic first choice was the fine art trade. His family had had connections with the business for three generations. Through his uncle Vincent (Cent), himself an art-dealer, a position as clerk was found for Vincent at the well-respected firm of Goupil's, which had branches in Paris, London and The Hague. Vincent was duly assigned to The Hague where he made a good impression, doing well enough to be offered promotion. After a spell there, he spent some time in the Paris office, until his impatience with dealing in art began to get the better of him. He fell into the habit of discussing potential buyers' choices in critical terms rather that in those of a salesman, making fewer and fewer sales in the process. This, and an unrequited love affair, settled the issue. He left the fine art business forever.

In the course of his travels between the various branches of Goupil's, Vincent developed a particular affection for London. He now began to scan the advertisements in English newspapers for a post as a resident teacher, and after four months, received a letter from a school in Ramsgate, offering him a month's trial. He was no sooner installed, however, than the proprietor announced his intention to move the school to Isleworth, a drab London suburb. Vincent decided to accept the situation: at least, he reasoned, he would be able to see something of city life.

More significant at this time was Vincent's awakening religious belief. He suddenly reported to his family that he had been engaged by a Methodist minister, who had a living nearby, and had begun to prepare himself for a life of piety. He took to wearing clerical garb and became enraptured with such pious works as *Christ in the Garden of Gethsemane* by the now-forgotten Ary Scheffer. In this new frame of mind, he began to see himself as a potential missionary.

His taste in art was increasingly affected by his flight into a state of extreme religiosity. It was not so much the excellence of the paintings that moved him as their relevance as biblical subjects. Later, on visits to the great galleries, he would be just as likely to succumb to religious paintings by Meissonier or Israels as those of Rembrandt.

Suddenly, having given a sermon in the local Methodist chapel, he became fired with the idea of following in his father's footsteps, a feeling he described as emerging from a deep underground tunnel into the light. He began to visit the sick and poor in the more sordid parts of London, where signs of poverty and depredation moved him deeply. His father's example now seemed to be the answer to his longings.

His family gave him instant encouragement. 'Do not mind being eccentric,' Theo assured him. 'Keep yourself to yourself, and distinguish

DORDRECHT TO CUESMES: _____

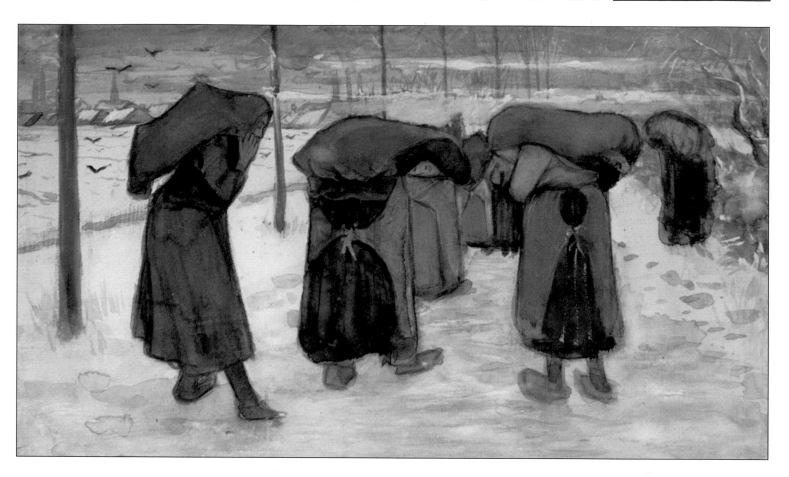

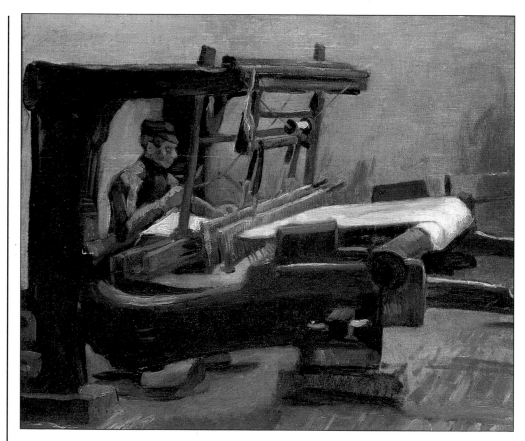

between good and evil for your own sake.' Vincent, by now established in lodgings and working in a bookshop in Dordrecht, reported how it felt to be among flowers and storks, larks and hawthorn hedges, a return to nature in all its glory. He was sharing a room with a young teacher, who described Vincent at that time, aged 24, as well-built, with reddish hair standing on end, a homely freckled face; and a penchant for reciting lengthy prayers.

Despite his mounting religiosity, Vincent failed his three-month trial period as a trainee mission worker. He was plunged into feelings of despair, which led to the decision to take himself off to that bleakest of all human environments, the Borinage province of Belgium; a land of coal mines, foul with fumes and smoke. After seeking a permit to pursue his evangelical mission, he entered a world far bleaker than the slums of London. He paints a stark word-picture of the miners – ill-educated but intelligent, brave and frank; short, square-shouldered, with

life in a wooden hut

LEFT
Women Miners, 1882

BELOW LEFT
Weaver Facing Right, 1884

RIGHT
Men and Women Miners Going to Work, 1880

BELOW
The Loyer's House, London, 1873-4

melancholy deep-set eyes. His own garb consisted of an old army tunic and shabby cap. He was given permission to work for six months in the village of Cuesmes. By way of preparation he gave everything he possessed – not much, by any reckoning – to the local poor, found a worn-out army greatcoat, stitched a couple of shirts together out of old pack-cloth, and took up quarters in a wooden hut. He would greet the miners returning from their shifts, do what he could for their welfare, and console them with readings from the Gospels. His father intervened, and found less squalid accommodation for him in a baker's shop. Moved by a

sudden impetus, he took up his watercolours and pencils to record the grim realities of life around him. His heart, as well as his hands and feet, bled for the miners. Drawing became his only release. The sombre, heart-

rending images of the miners' lives were wrenched from his own inner despair.

Unhappily for Vincent, none of his charitable works or sympathetic observations could earn him the approval of the Evangelical Committee which presided over welfare matters in the mining districts. Their report for 1879-80 mentions his involvement, but dismisses his contribution in no uncertain terms: 'It is evident that the absence of certain qualities may render the exercise of an evangelist's principal function wholly impossible. Unfortunately, this is the case with Mr. van Gogh. Therefore, his probationary period having expired, it is necessary to abandon the idea of retaining him any longer.'

Stripped of any support from the Church, Vincent took himself and his burning ideals to another area of coal-mining, where the plight of the miners had brought them to the brink of setting the mines on fire. He was instrumental in persuading them from taking such suicidal action by urging them not to destroy 'everything that is good in mankind'.

AMSTERDAM:

In May 1877, he went to stay with one of his uncles in Amsterdam, intent on making a serious study of theology. He was held back, however, by his inability to master Latin and Greek, and was forced to pursue a less exacting course of Gospel studies in Brussels. His correspondence home at the time was assuming a more anguished tone, as if Vincent deep down knew the mental and emotional obstacles standing in his way. He described himself as 'a man of passions', apt to behave foolishly, which he later regretted.

The mood passed. Perhaps there was another way of glorifying God – by becoming a painter. He began to consider the practicalities of taking up painting as a career. He dreamed of country locations, preferably in the company of other painters, where he could live cheaply on the little he could afford. He bought a couple of suits of workmen's clothes and was thinking of acquiring a few odd garments which would do for his models, once he got started in earnest. In a family such as his, with well-off relatives in the art business, he could surely expect some financial help to enable him to embark on a career of his own. Or, failing a cash subsidy, the least he could expect was an introduction to influential members of the art world. It occurred to him at this point that he would become a practising artist, living and working among the poor in the industrial heartland of the Low Countries.

His primary exemplar at the time was the renowned Barbizon painter, Jean-François Millet, whose powerful studies of French peasants had made a deep impression on him. Casting around for similar subjects, he found several in his own neighbourhood, from the family gardener to an old, sick farmer sitting at his hearth, with his head in his hands and elbows on his knees. Unfortunately these were not palatable themes. The great Millet himself, who exhibited similar scenes of working life at the Salon in the 1860s, had been accused of being a socialist, an agitator and an anarchist.

Domestically, the situation was sensitive. His father disapproved of all appeals for financial help which Vincent now began posting to members of the family. At this time, when relationships were somewhat strained, he upset them further by falling in love with a recently-widowed cousin, Kee (Cornelia) Vos-Stricker, while visiting his parents in Etten. The combination of the pathos of her situation, combined with the recent loss of a child, was enough to kindle romantic notions of chivalry and protection in Vincent, inspired as much by Kee's beauty as the tragedy of her recent losses. At 28 he was highly susceptible to these romantic fancies and could easily see himself in the role of selfless lover. When he declared himself to Kee, she firmly rejected him, not even bothering to respond to the torrent of letters that followed. An inevitable sense of

deflation and disappointment followed. Pondering his drawings of the time, he detected in them a profound melancholy. He mourned: 'I felt that love die within me.'

Eager though he was for self-improvement, he seems to have had bad luck in his search for instruction, even allowing for the personal eccentricities which would have held him back in whatever field he might have chosen. His slovenly appearance and brusque manner did not help. If he did not give vent to his feelings from time to time, he felt he would explode. He was growing tired of his parents' use of such terms as 'indelicate' and 'untimely' to describe his behaviour. The day finally arrived when he was ordered out of the house after telling them that the whole basis of their belief was 'horrible'. Theo, for once, rounded on him. He demanded to know what made Vincent spoil their father's and mother's life so gracelessly.

That there was a sensitive side to Vincent is apparent in a tender early drawing of a baby's cradle. He explained that he wished, at this time, to produce drawings that would truly touch people's hearts. While admitting that some found him eccentric and disagreeable, he was certain that his work would redeem him in the end. Within a few years, the family would begin to see works of his that would be compensation for their sacrifices. He looked forward to showing them his latest experiments with colour: his choice of subject- matter was also widening. He gave a few examples: a pollarded willow; a dead tree near a stagnant pool covered with reeds; a distant train-shed where the tracks crossed each other – scenes

'working through an invisible wall'

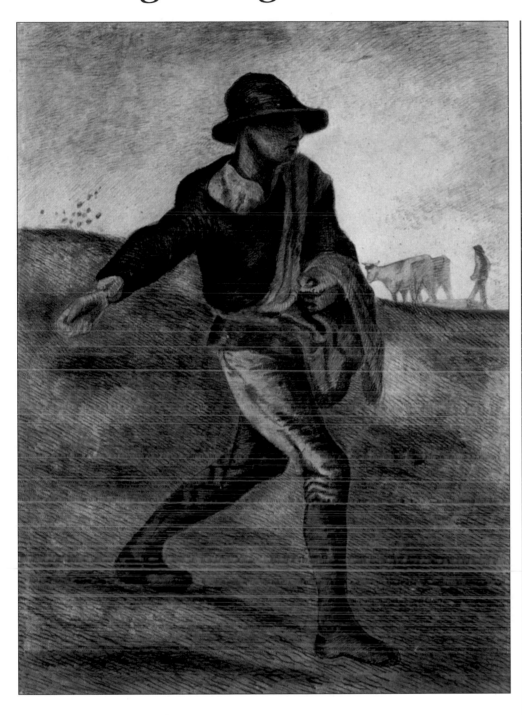

undermined and drilled through. Great events were not accidental – they must be willed. Vincent compared the artist's curiosity to a visit behind the scenes in a theatre. At the same time, his thoughts were still centred on the figure. He described a model he had been working with, a boy hod-carrier with a flat nose, thick lips and coarse hair, yet blessed with extraordinary grace. He had watched this boy at work at a nearby boatyard, where he and others like him were dragging barges filled with stones. He recalled an ironical line from one of his favourite English authors, Thomas Carlyle: 'Blessed is he who has found

> *Vincent compared the artist's curiosity to a visit behind the scenes in a theatre*

his true vocation.'

His sister, Elisabeth, left a vivid account of Vincent's appearance as a young man – back slightly bent and a habit of letting his head hang; red-blond hair, cropped close, hidden under a straw hat. A strange face, not particularly youthful, the forehead full of lines, the eyebrows on the large, noble brow drawn together as if in deepest thought. The eyes deep-set, now blue, now green according to the mood of the moment. In spite of his awkward and ungainly appearance, he gave the impression that he possessed an intense inner life. This description bears a remarkable resemblance to the searching self-portraits that were to follow.

It was high time he sought advice, and even encouragement, from an established professional painter. He considered that even from relatively untalented artists, one could pick up useful tips. As it happened, there was already a highly respected artist in the family – Anton Mauve, a cousin of his mother's by marriage; one of a group of artists of the Dutch School

which he could imagine the signal-man in his smock and little red flag experiencing on a rather gloomy day.

Vincent continued to feel anxious about his parents. They were the kind of people who were becoming rare these days, he now realized, but who were out of sympathy with the times. They could not understand that the figure of a labourer or a stretch of sand, sea and sky were serious subjects to paint. He hated the thought that they were doomed to perpetual

disappointment in him. But that was the penalty of not looking at things the way he did.

More than any of his contemporaries, Vincent agonized over the technique of drawing. The whole process was like working through an invisible wall that stood between what the artist felt and his means of expressing it. How to break through that wall was Vincent's over-riding obsession. Pounding on it, he found, was no use – it had to be

17

AMSTERDAM: *help from an exhibitor*___

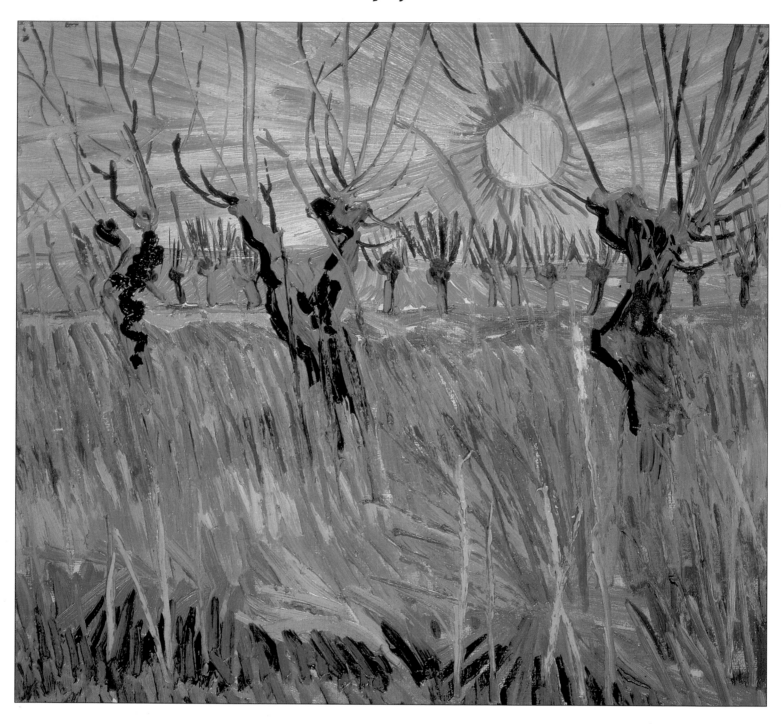

whose work set out to reconcile the *plein air* tradition so dear to the Barbizon painters, headed by Millet, with that of classical landscape.

Mauve agreed to do what he could to provide Vincent with a sound basis from which to develop his skills. He was soon introducing him to the elusive technique of watercolour, which Vincent found absorbing. One early result of this tuition, from July

Vincent's alarming instinct for self-destruction eventually got the better of him

ABOVE
Willows at Sunset, 1888
RIGHT
The Cradle, 1882

1882, is a landscape painted at Scheveningen. What may be his earliest surviving oil painting, *Beach at Scheveningen in Calm Weather*, dated August 1882, owes its genesis to these sessions with the long-suffering Mauve. That Vincent did not persist

Vincent's roots lay firmly in the Brabant region of southern Holland. Here, his father had his ministry and Vincent spent his schooldays. His interest in religion inspired an intense desire to help those less fortunate than himself and led him to the deprived mining areas of the Borinage and the desolate peat fields of Drenthe. In 1881, on a visit to Etten, he fell in love with his cousin Kee, unhappily unreciprocated. He was to fare no better in Amsterdam, in 1882, when his attempts to create a family life with Clasina Hoornik were doomed to failure.

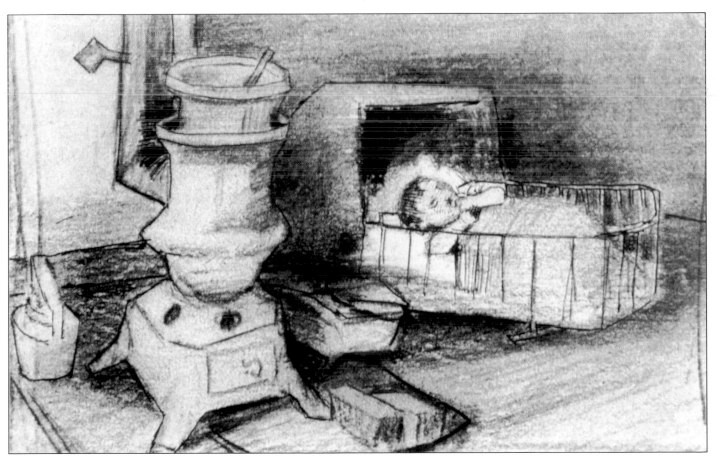

THE HAGUE: *a tiff with the master*

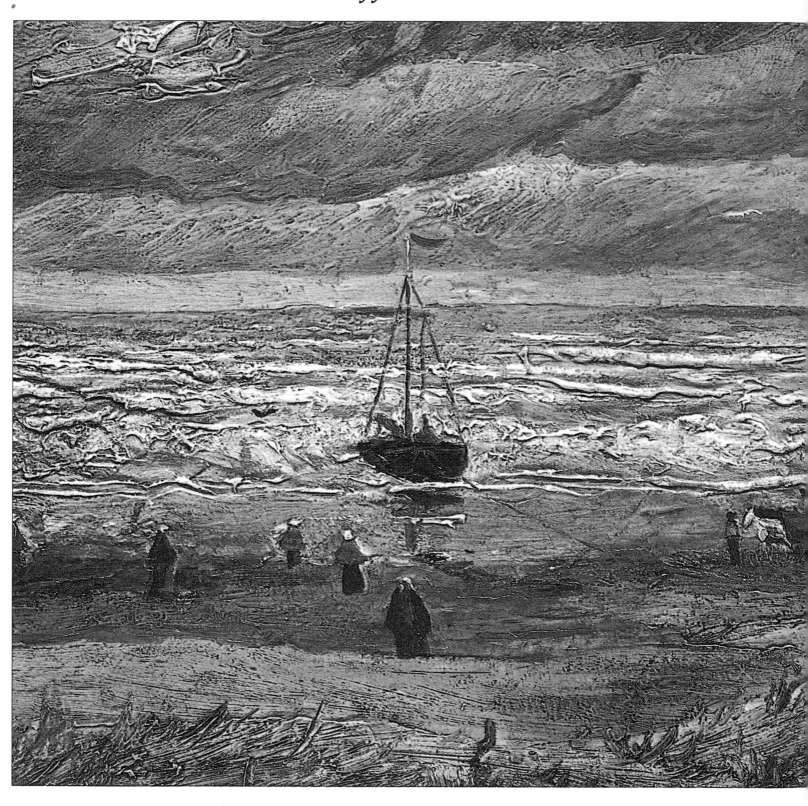

with the medium of watercolour may be due to the fact that it refuses to be roughly handled: unlike oils, it prefers to smile and glance over the surface rather than be subjected to the rough weight and passion of a Van Gogh brush-stroke.

ABOVE
The Beach at Scheveningen in Stormy Weather, 1882

RIGHT
Sorrow, 1882: The subject is Clasina Hoornik, whom Vincent knew as Sien. (See overleaf).

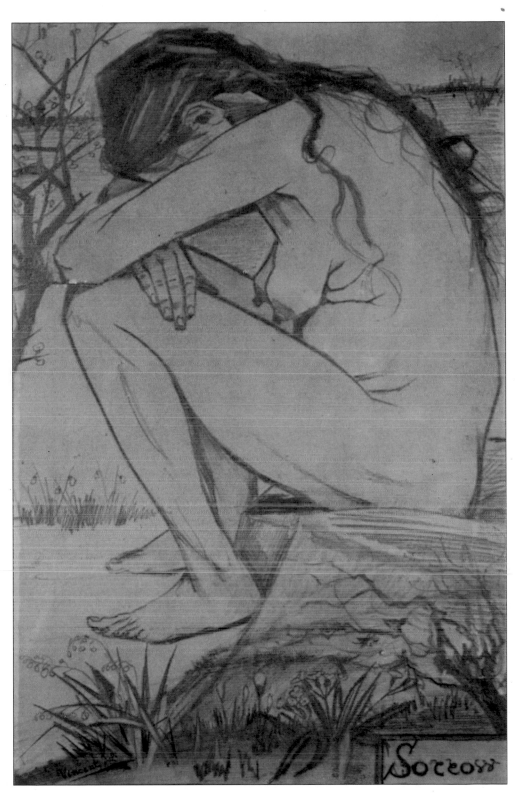

However, Vincent's alarming instinct for self-destruction eventually got the better of him. After bitter scenes in which he called the blameless Mauve 'vicious', the master wrote him a note saying that he would have nothing more to do with him for two months. Vincent later tried to make amends by writing to Mauve, congratulating him on the success of a recent painting. There was no reply. Seven years later, in Arles, on returning home with a painting he had just finished of a peach tree in blossom, Vincent was to find a letter waiting for him. It was from his sister, telling him that Mauve had died. Vincent later confessed that it brought a lump to his throat. He wrote on his painting: 'Souvenir de Mauve. Vincent.'

'MOMENTS OF INFINITY':

A conflict now arose between Vincent's sense of Christian duty towards the poor and his realization of its incompatibility with the artist's way of life. He was looking for an escape from what he saw as a caged-in existence. After a winter in Brussels, which he spent painting, copying and drawing in the museums, he decided to return to The Hague.

It was to be a fateful change of scene. Up to now, he had had little success with the opposite sex. His intense manner and stark appearance did little to help. After two rejections, each of which left emotional scars, he embarked upon a relationship with a woman he picked up off the streets, neither young nor beautiful, but tall and well-built, with the hands of a working woman. Life had not treated her kindly. On the other hand, he reasoned that every woman of every age can give a man 'a moment of infinity'.

Her name was Clasina Maria Hoornik; she was a prostitute; and Vincent affectionately called her 'Sien'. He had invited her to model for him while sharing with her what little he had. He eventually became devoted to her and her two young children. With the help of his monthly remittance from Theo, they could surely survive. To Vincent this seemed, at last, to be an approach to happiness. The reality, however, was that he had contracted a venereal disease and that Sien was pregnant.

Vincent posed Sien for a drawing, *Sorrow*, which he claimed was the best he had ever done. With Theo's help he was able to move into a larger apartment with a studio, a kitchen and a bedroom in the loft. In spite of everything, painting had once again become a pleasure.

From his own accounts it would seem that he spent all day painting in the tumbled living-room with its grey-brown wallpaper, muslin curtains, two easels, an alcove stuffed with painting materials, a closet laden with brushes and pots and a jumble of books. The living quarters contained table, chairs, oil-stove and a small iron cradle with a green coverlet.

The drawings piled up. Vincent wrote to Theo excitedly that painting was now a positive joy. He also described in touching terms his new-found family life: 'When I am with the woman and the children and the little boy comes creeping on all fours towards me, crowing with joy, I haven't the slightest doubt everything is all right. When I am at work he pulls at my coat or climbs against my leg till I take him on my lap. The child is always happy. If he keeps this up his life will be happier than mine.'

His studio window looked out on a canal full of barges loaded with potatoes and rear views of houses in the course of demolition; part of a garden; and, more distantly, the quay with its rows of trees and street-lamps, a scene that reminded him of Ruysdael or Vermeer. But Vincent's dream was becoming tainted by the reality of his situation.

On Sien's part there was merely thankfulness that she and her children were being cared for rather than having to live on the streets. On Vincent's, there was a growing resentment of the squalor they shared, the ever-present reek of liquor and tobacco. Theo, who visited during the summer of 1883, urged his brother to end the affair. Still Vincent resisted. He could not think she was bad, he pleaded. How could she ever have known good? But the fantasy had to end. He confronted Sien, gave up the lease on the studio, helped to settle the infants, gave Sien a sum of money, and went his way.

The Sien episode had lasted 20 months. In that time Vincent had done very little work with the exception of what he regarded as his finest single figure drawing, his study of Sien naked, crouched in an attitude of despair, the one he called *Sorrow*.

He now thought he might take himself off to England for he was much attracted to the type of black-and-white illustration fashionable in social-conscious journals and magazines of the time. However, on economic grounds he settled for Drenthe, a lonely inland area in the bleak north-east of Holland, notable

only for its seemingly endless peat-fields. It would save him about 2,000 guilders a year in living expenses, mostly on rent; it would be a good opportunity for him to take stock of himself.

He could not quite decide whether to stay in Holland or return to England but he had enjoyed his visit to London in the 1870s and hoped to repeat the experience. It was there, as a mere youth, that he had acquired his

a new-found family

Landscape with Church and Farms, 1885

life-long admiration for the illustrators of the day, masters of black-and-white wood engravings produced for such journals as the *Graphic, Illustrated London News* and *Punch*. Fluent in English from his late teens, he had widened his cultural interests far beyond his native shores. He had read and enjoyed such classics as *Uncle Tom's Cabin, Jane Eyre, Adam Bede, The Mystery of Edwin Drood* and *Pickwick Papers* – novels, which within the culture of the Victorian age, challenged moral attitudes to the grim realities of city life – poverty, ill-health, injustice – but which held fast to the hope that the human spirit would ultimately prevail. Vincent had amassed a large collection of illustrations in this genre, some of which he drew on as subject-matter for himself. Though such aspects of modern life had their equivalent in Holland, the impulse to use them and

23

DRENTHE: *the drama of desolation*

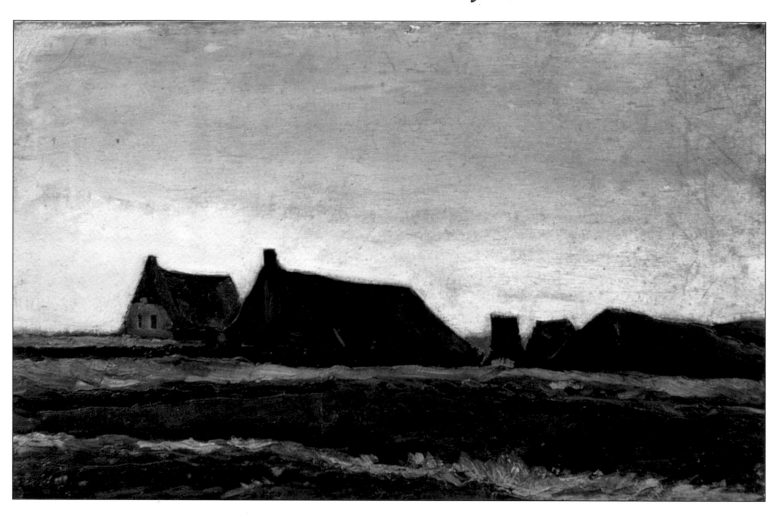

eventually make them his own began in London.

All his life Vincent regarded these artists and engravers, involved in social commentary, as belonging to the company of such favourite painters as Dürer and Delacroix. He had vivid memories of the illustrators whose work had most impressed him, among them, Houghton, Fildes, Barnard, Herkomer, Walker, Small. He respected their down to earth attitude to what they saw around them and their refusal to pander to the rich and powerful. However, within a few weeks, on 11 September 1883, he was on a train heading for the sadly-deprived province of Drenthe.

Arriving bedraggled and weary, he was at first refused entry to the hotel by a suspicious proprietor who only relented on hearing that Vincent was a pastor's son from Brabant. His first step outside was more encouraging; an old mill, a farm, a

lock, crawling barges bearing peat, locals in peasant costume, homesteads of turf and sticks. He succumbed at once to the character of the place, moved by the sombre beauty of an unsophisticated way of life, uncomplaining poverty of the kind he recognized in the paintings of Millet. On close examination, the punishing reality of life in such places, the heavy toll on health, the prematurely aged women, their beauty so short-lived, struck him with a new force.

As he had discovered in other such communities, the people were not eager to be painted or sketched, even indoors away from the prying eyes of neighbours. Drenthe, nevertheless, possessed a stark nobility of its own, at times bathed in light, graduating into distant mists. With the landlord's children skipping at his heels, Vincent made an excursion to the ancient settlement of Zweeloo, with its stunted little church crouching among

cornfields in a flat landscape where figures appeared dwarfish by comparison. To his eye, these gaunt expanses assumed a quality similar to the most beautiful of Corot's paintings.

From the map, he had chosen an area of Drenthe which showed up as a large blank patch devoid of place-names, crossed by a solitary canal which appeared to end abruptly in the middle of an area marked simply 'peat-fields' – a place of desolation. But loneliness had now become more appealing to Vincent than company. He felt a need to renew himself, and knew that the further away he went the more likely he was to succeed. Parting from Sien and the children had been wretched, though he had left behind a number of possessions which would be useful to them. At the same time he admitted to himself that things would not be easy for her.

In choosing Drenthe, he was

LEFT
Farms, 1883

BELOW
Peat Boat with Two Figures, 1883

deliberately turning his back on material needs and possessions. He was moved by the sight of the homes of the people in this inhospitable place, with their moss-covered roofs and blackened chimneys; the lonely sheepfolds and shepherds; even the cruel fluctuations of weather dismayed him. He began to see the people with a keener eye than ever: a working woman's breast, he noted, had a heaving movement that was the opposite of voluptuous, arousing in him pity and respect. As he had noticed before, the people of this secretive place were reluctant to let him draw them, so he was forced to have himself pulled along hidden inside a cart, in order to sketch them unobserved. Soon winter set in and drove him indoors. Much against his will, but close to the end of his tether, Vincent now decided that the only place left for him to go was home.

Whatever the benefits in broadening his experience of life, it seemed to Vincent that Drenthe was no place to expect a breakthrough in his career. Acting on a sudden impulse, he left the hotel without even saying his good-byes. One of the landlord's daughters said later that he left behind piles of drawings, along with finished works and pots of paints. For years, she recalled, the family did not touch them. In the end, her elder sister burned them all in the stove having abandoned hope of his ever returning.

Vincent eventually turned up at the family home where he was received with mixed feelings. He told his brother: 'They feel about me as they might feel about a big rough dog who runs into the room with wet paws, getting in everybody's way, barking.' On an impulse, he returned to The Hague to visit Sien. He was so distressed by the experience that he hurled accusations at the blameless Theo for letting things slide into such heart-breaking misery. And still Theo's monthly payments kept on arriving.

A brief account of Vincent at work survives in the recollection of an old miller at Nuenen who remembered watching him painting the mill at Opwetten, oblivious to the group of urchins who were spying on him. He would sit on a chair, fixing his subject with an unblinking gaze for several

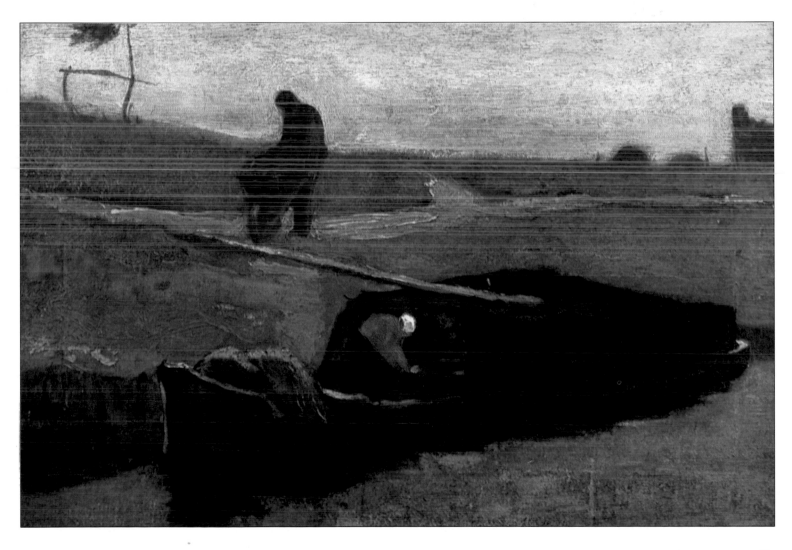

NUENEN: *a bond with the potato-eaters*

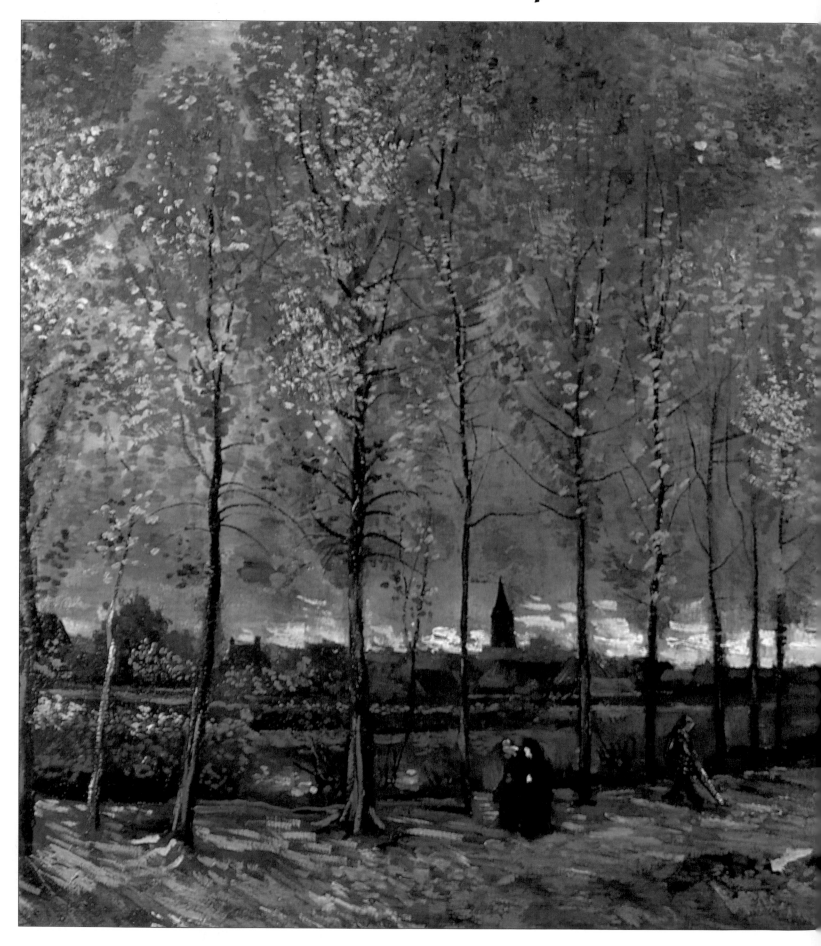

minutes at a time, then suddenly jump up, apply two or three brush-strokes, and return to the chair. His powers of concentration impressed everyone who watched him at work. His response to sudden revelations of natural beauty were equally intense: 'How does God do it?' he exclaimed to a young admirer, Anton Kerssemakers, eyes half-closed against a sudden blaze of sunset.

He would give up ten years of his life, he once said, with nothing but a crust of bread, to sit in front of Rembrandt's *The Jewish Bride* for just a fortnight. When he was about to leave Nuenen, he brought Kerssemakers a farewell present – a study of autumn so newly painted that it was not yet dry. His friend, delighted, asked why Vincent had not signed it. He was told that there was no need: everyone would recognize his work in the end and write about him when he was gone.

His slowly maturing talents reveal themselves in the landscapes he was now beginning to produce, including a haunting study of two figures with a plough against a sinister green sky; a watermill at Nuenen in which a lighter palette is beginning to emerge; a series of portraits of peasants and workmen, a *Cottage with Woman Digging*, a *Lane with Poplars*, which prefigure subjects that lay ahead; and portrait studies of working women. Of these, Vincent considered his painting of peasants sitting down to a meal of potatoes the best thing he had done. It was the only painting that he agreed in principle to exhibit, partly because it was painted, he claimed, in the tradition of Millet. He urged Theo to make a special effort to show it around in the art trade: he saw it as a reflection of his natural bond with the common people.

There followed a virtual torrent of paintings and drawings of rustic cottagers in their working clothes. Dressed like that, he said, a peasant girl was more beautiful than any great lady, her dusty, patched blue skirt and bodice having acquired their delicate faded hues from weather, wind and sun. To Vincent, a peasant was more

LEFT
Lane with Poplars, 1885

BELOW
Two Peasant Women, Digging, 1885

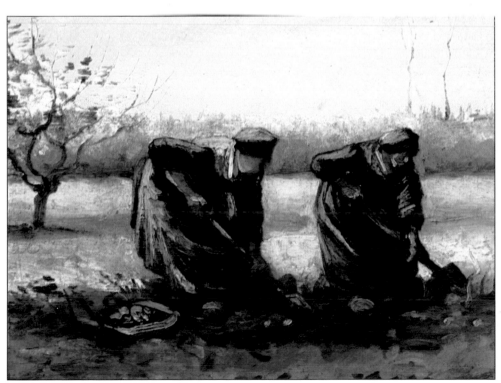

RETURN TO ANTWERP:

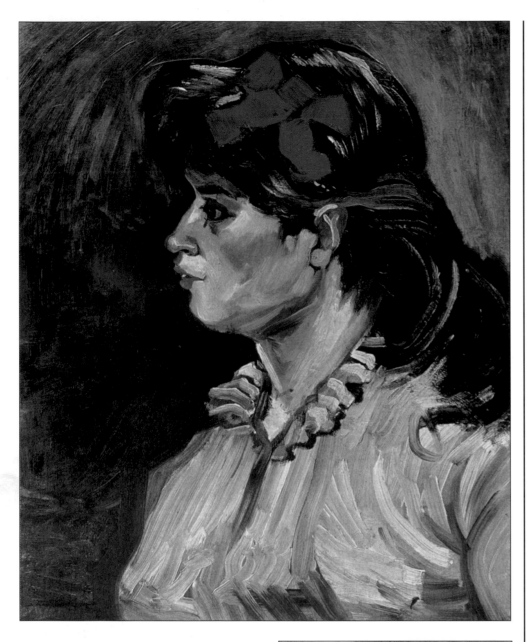

deep thought. He cooked for himself, brewing coffee all day on a small stove and seemingly eating nothing but bread and an occasional bite of cheese. On his walks he could be seen taking a nip from a brandy flask.

In March 1885, when at work on further studies of peasants, he received news that his father, whose quarrels with his son had caused such rancour within the family for nearly ten years, had died. Vincent's rejection of his family's faith had deeply wounded them all. At times, his father could not even bear to hear his name mentioned in the house. Vincent had stood his ground. His own articles of faith were enshrined in a single painting, *The Potato Eaters*.

Vincent would only discuss painting with close friends. Once, when asked why he did not sign his name in full, he replied that Van Gogh was such an impossible name for foreigners to pronounce that he had long since settled for 'Vincent'. He was equally adamant when the well-meaning Mauve reproached him for preferring his fingers to a brush. What did it matter, demanded his exasperated pupil, if he painted with his bare feet, so long as he got it right! His work at this time was dark-toned and earthy in the Dutch tradition; the same earthiness inherent in rustic cottagers, eating from the same hands that had dug the earth.

If Vincent does not always seem to be the hero of his own life-story, let us

ABOVE LEFT
Portrait of a Woman with Red Ribbon, 1885

vividly real in his working garb than when he went to church on Sundays in a dress-coat. He declared: 'If a peasant picture is full of smells of bacon, smoke and steam, in the way that a stable smells of dung – that's right. And if a field smells of corn or ripe potatoes or manure, that's healthy too – especially for people fom the city.'

A life of bohemian poverty seems to have been a necessary part of Vincent's self-esteem. Even when offered such basic comforts as a living room as well as a bedroom, he preferred to sleep in the corner of an attic, under the tiles. He went on long walks alone, and at home sat silent in

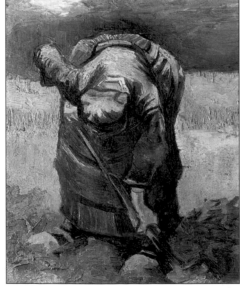

LEFT
Peasant Woman, Digging, 1885

OPPOSITE
The Potato Eaters, 1885

'smells, smoke & steam'

spare a thought for Theo. Thanks to his long periods of financial support, Vincent was literally kept alive. Theo's income and commissions from the art gallery were never substantial; at times they dwindled to a point when the monthly allowance he sent his brother brought him close to penury.

Vincent, his all-consuming ambition devouring so much of his own energy, made demands of his brother that bordered on persecution. In February 1884, writing from Nuenen, the family home, he accused Theo of not doing enough to help him sell his work. He insisted that his brother frankly admit whether or not he intended to interest himself in selling his paintings or whether – an unkind thrust – Theo's dignity would not allow it. In one of the most disagreeable letters he ever wrote to

Vincent splashes out – Japanese prints on the walls, an oil-stove and lamp, and a return ticket in his pocket

Theo, he ended with the threat that he would take himself off abroad, where he could do whatever he took it in his head to do, 'a stranger among strangers'.

Vincent's priority was now to sell some pictures. He was in no doubt that the place to do this was Antwerp. He had been offered a return ticket by his friend Hermans, a retired goldsmith in Eindhoven with a collection of antiques, who had once commissioned Vincent to produce a series of village scenes for him. Vincent duly arrived and found a room above a colour-shop. Here he made himself comfortable, by his own spartan standards, pinning his Japanese prints all over the walls and splashing out on an oil-stove and lamp. He then embarked on an intensive round of the picture

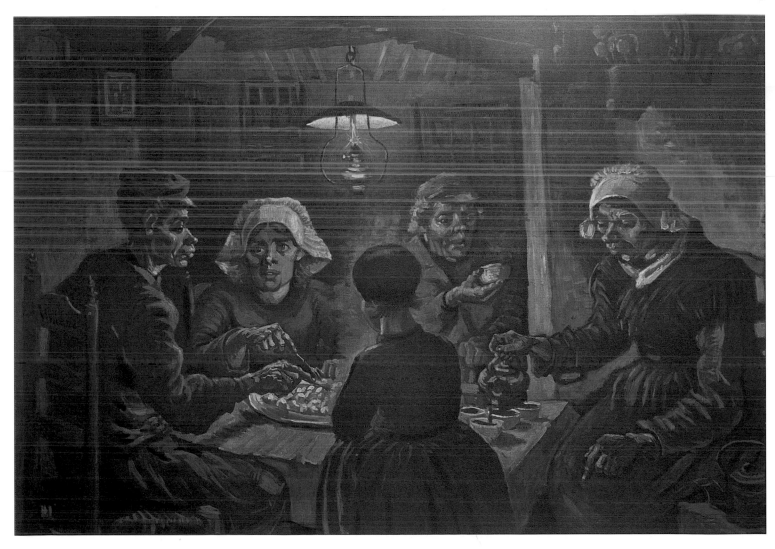

ANTWERP TO PARIS: *back to art school*

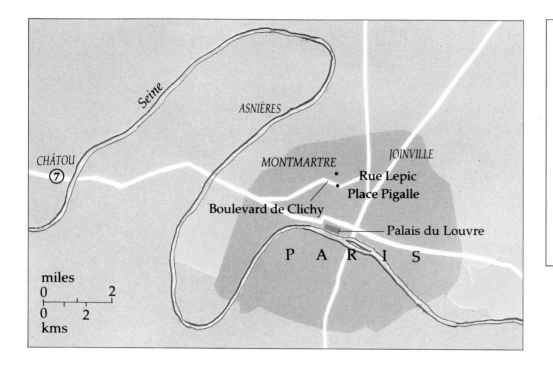

Life in Paris was divided between the Louvre and Corman's Academy in Montmartre where Vincent shared Theo's apartment near the Place Pigalle. Later, he extended his interest to the Seine and suburbs to the north-west.

galleries; walked the narrow streets with their tempting shop windows; dropped into bars boisterous with sailors; attended a dance-hall where he made a couple of vivacious sketches; admired the Rembrandts and Rubenses, discovering in Frans Hals a colourist as vividly adept as Veronese and Delacroix; decided that Rubens's figures in his religious paintings looked like dinner-guests who had retired into a corner with indigestion but that his women were superior to those of Boucher. He also kept himself busy by painting the roof-tops from his window, and picked up a couple of women on the dockside who agreed to sit for him in return for one portrait each by way of payment.

His insistence on painting the truth as he saw it rather than a glamorized version, tended to get him into trouble. Should one start a portrait from the point of view of the clothes or the soul? Meanwhile, he was practically starving, reduced to his familiar diet of dry bread and milk. He had managed to afford only three hot meals since he arrived in Antwerp. His state of health was too poor for him even to digest the food he craved. To keep hunger at bay he smoked ever more furiously. He felt a perverse pleasure when told by a

doctor that he looked like a bargeman or iron-worker, but was genuinely fearful that he might have to give up painting altogether. A macabre image, produced by Vincent at this time, a skull with a cigarette, could be seen as an indicator of his encroaching fear of death.

The effects of these depredations on his general appearance are grimly obvious in a series of self-portraits from this time, executed as they are with his usual raw honesty. Fast running out of new ideas for subjects to paint, and unable to afford models, it seemed a good idea to join an art school where models were provided. He decided to apply to the Academy where at least he could expect to paint and draw from life. At the back of his mind was the nagging thought that he might by now be too old. However, he presented himself for admission, armed with some recent work, and was accepted as an art student. He was now 32 years old.

So far, his attempts at figure drawing had brought him nothing but trouble. At the Academy in Antwerp a fellow student remembered his disruptive behaviour. He would arrive in workman's blue blouse and a fur cap, and instead of the conventional palette would use a piece of wood torn

from a packing case. On one occasion, instructed to paint a pair of wrestlers stripped to the waist, Vincent attacked the task with such vigour that he splashed paint all over the floor, whereupon he was ordered back to the drawing class. There he worked no less feverishly, strewing the floor with discarded sketches, repeating the same subject over and over again.

The day came when the class was set to draw a cast of the Venus de Milo. Vincent endowed the goddess with the shape and form of a Flemish matron. At this point, his taskmaster could stand no more. But, far from abashed, Vincent countered his insults with arguments of his own. Didn't anyone know what a flesh and blood woman really looked like? A woman needed hips and buttocks and a pelvis that would hold a child. That was the reality – a reality that Vincent van Gogh continued to celebrate in his art.

After these experiences, he felt more than ever in need of a competent and professional mentor to help him on his way. Antwerp, he discovered, had its limitations, whatever the merits of its Academy. There was only one place to which he could take his talents and ambitions, and that was Paris. Theo's initial reluctance to share lodgings with him did not affect the

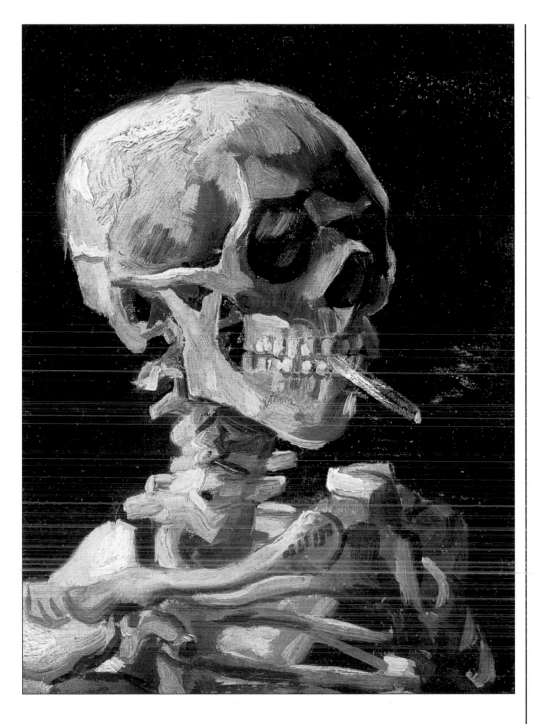

Skull with Burning Cigarette, 1885/6

moment, the brothers decided to share Theo's small apartment near the Place Pigalle. It was cramped, but they were together; at least it would do until something more convenient came along. By enrolling in yet another academy, Vincent reconciled himself to the traditional practice of working from plaster casts, but determined to remain faithful to the spirit of the 'realists', notably Millet, whose work he most ardently admired. He had heard that in Paris there was not the same insistence on traditional methods. The studio that appealed to him most was that of Fernand Cormon, under whose eye students were set to paint both the male and female nude. Vincent resolved to put in some extra practice of his own, drawing ever more frantically at the Louvre; before long, he was admitted to Cormon's studio at 104 Boulevard de Clichy.

Though he paid little attention to his fellow-students, they formed a respectful opinion of Vincent and his work. For all its apparent idiosyncracy, Cormon's had about it an honesty of purpose. According to one member of the class, Vincent was touchy in discussion and liable to suddenly flare up in an alarming fashion. Far from skimping his studies, he was often to be seen in the studio in the afternoons, working on his own. He did not, however, bother to conceal his contempt for traditional views of academic technique; what he had to say in paint he said in his own way.

One of Cormon's pupils who left an account of his time there, Robert Fernier, recalled that a quotation from Kant was spelt out in capital letters all along one wall. It said: 'The new must wait their turn to speak, and their turn never comes.' This was hardly a message that Vincent was likely to heed, even if it was not intended to be taken seriously. Reports of the working conditions at Cormon's *atélier* tell of walls deeply stained with palette scrapings and a constant fug of oil, dust and tobacco smoke. The 60 or so students working there included a youth named Emile Bernard, shortly to be dismissed for painting stripes

brothers' feelings for one another. Vincent continued to press Theo, who in the end began to see the wisdom of sharing an apartment together. Perhaps, loving his brother as he did, he simply gave in – the usual outcome of any disagreement between them. Vincent turned his thoughts to the various academies. He decided that he would like to spend a year at Cormon's, doing nothing but figure drawing and at the same time visit the Louvre for practice drawing. For the

PARIS: *the climax of Impressionism*

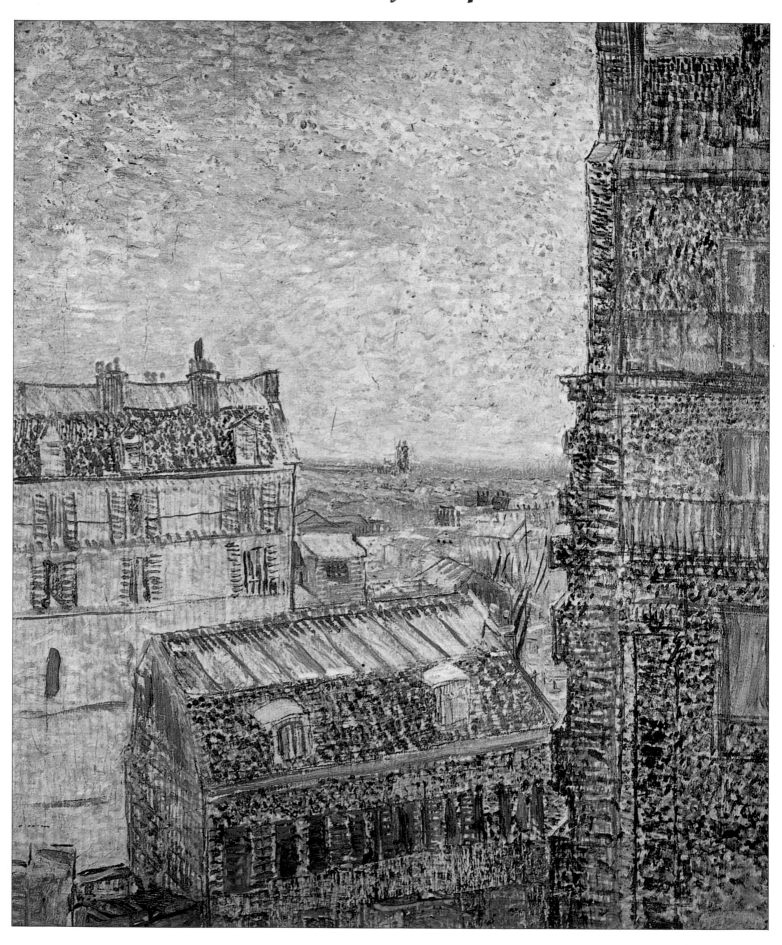

over the dowdy backcloth which hung behind the platform where the models posed. He and Vincent, ten years apart in age, became friends in the brief time left to Bernard at Cormon's. This was to be as fruitful a friendship as ever Vincent was to enjoy. For his part, he chose at this moment to paint a pair of battered boots. It was no surprise that, in the annual competition to identify the most promising students, assessed by no less than 25 judges, Vincent was unanimously judged to have come last.

Cormon, shaken by signs of insubordination, now closed his school for a full term. Vincent did not go back. Neither did the young Toulouse-Lautrec who considered that the kind of academic perfectionism current at the time was guaranteed to render art sterile and bankrupt. Vincent wrote to Bernard that summer of his disillusionment with art schools. They not only taught you nothing about art but not much about the art of living either.

In 1886, though he had been painting for a mere six years, Vincent's career was coinciding with the climax of the Impressionist era. In that year Monet was showing at the fifth International Exhibition in Paris, and Durand-Ruel, the Impressionists' dealer, took 50 of his works to New York, along with several by Pissarro and Sisley. Monet also took part, together with Renoir and Pissarro, in the eighth Impressionist exhibition that year, where Pissarro met Vincent through his contact with Theo. Cézanne, though making virtually no headway with the Impressionist group, had inherited a fortune from his father in Aix-en-Provence, whence he retreated to paint for the rest of his life.

Vincent had probably never even heard of the Impressionists until he arrived in Paris. Even if he had, their choice of subject-matter would probably not have appealed to him or caused him to emulate them. Their predilections lay too solidly with the bourgeois element of society and Vincent would have considered them somewhat frivolous in their

LEFT
View from Vincent's Window, 1887

BELOW
Vase with Poppies, Cornflowers, Peonies and Chrysanthemums, 1886

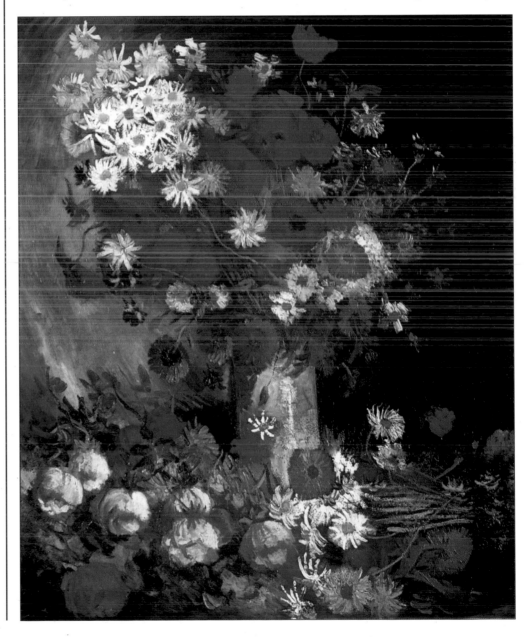

preoccupation with capturing in an instant, the essence of each fleeting experience. Vincent's own background determined the values that he struggled with all his life; the solid certainties of a strict church-going community who placed duty above pleasure, the scriptures before novelty and reward. Vincent's was a well-respected family, and the art-dealing enterprise in which they had an interest was in all ways respectable. That Vincent failed to make a place for himself in their world struck them as both odd and ungrateful. Even as an office-boy in Goupil's London branch he had upset them by falling in love with his landlord's daughter, taking a

PARIS: *inspiration from the East*

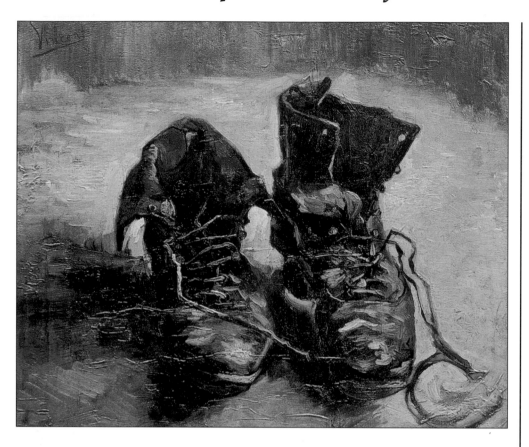

ABOVE
A Pair of Shoes, 1886

OPPOSITE
Bowl with Zinnias, 1886

job teaching French, and, on his return to Holland, wasting his talent for drawing, as the family saw it, by plunging himself headlong into the lives of the miserably poor.

The faithful Theo, fully aware of Vincent's turbulent relations with their family, now hastened to reassure them. They would not recognize him, he said: he was fast making progress in his work, and his spirits were higher than usual. Friends kept sending him bunches of flowers, which he was using for still lifes. Theo himself, at this time, was making plans to disengage himself from his employers, in the hope of starting a gallery of his own specializing in avant-garde artists. Vincent was all in favour, and urged him on. Theo's business project came to nothing. But he was able to kindle interest in Vincent's work among his colleagues: the still lifes of flowers were well-received – tiger lilies, dahlias, gladioli – all in contrasting bowls or vases. Vincent gave Paris credit for stimulating this outburst of pure colour-painting. However hard life there might be, he told the family,

> *Vincent showed no interest in the Parisian crazes. But the novelty of all things Japanese caught his fancy*

'the French air clears the brain. It does a world of good.'

In other respects Paris was disappointing. For one thing, Vincent's love-life showed no improvement. At the same time, he was totally uninterested in the influences that were making their way into avant-garde painting, such as the new uninhibited choice of subject-matter, which ranged from street-life and music-halls to the circus and the cabarets. But the current craze for anything and everything Japanese, caught Vincent's fancy at once.

This passion for things Japanese, which was widely shared by the Impressionists, was a long-standing interest of both Vincent and Theo: between them the brothers had accumulated a collection of some 400 Japanese woodcuts. Vincent had written to Theo from Antwerp at the end of 1885, describing how he had used a number of them to decorate his walls – figures of women in gardens or on the beach; horsemen, flowers, knotty thorn-branches. In Paris, Vincent grasped the opportunity of seeing many more examples and painted several of his own devising, among them *Flowering Plum Tree, Bridge in the Rain* and *The Courtesan*. In his contacts with fellow-artists living in Montmartre, he could hardly have escaped the influence of the Impressionist movement.

One popular meeting-place was the modest premises of a colour merchant and picture-dealer known as Père Tanguy, a lively rendezvous where there was no obligation to do business. Theo soon noticed that Vincent's palette was growing lighter. He was attempting to put some sunlight into his work. Equally influential were the late works of Monet, examples of which were to be seen at Tanguy's and also at Theo's, since he was now buying Monets for stock. Vincent painted Père Tanguy three times and included a number of secondary motifs, most notably Japanese. Vincent admired what he perceived to be the grace and order of Japanese culture; a stark contrast, as he saw it, to the values of Western

society. He began to see his collection of Japanese prints as an indication of what the future could be like; how beauty and serenity would cast out ugliness and squalor.

Family considerations apart, Vincent was at last beginning to see a way forward. He was now one of a group of interesting friends, more stimulating than the waifs and strays of not so long ago. There was Lautrec, Bernard, and the magnetic Gauguin. He was acquainted with the Neo-Impressionists and Pointillists, Seurat, Signac and their circle. He had found an admirer in the respected veteran, Camille Pissarro, the most devoted and persistent of the Impressionist 'painters of light'.

Bernard, describing Vincent's appearance at this time, recalls him as red-haired with a goatee beard, rough moustache, shaven skull, eagle eye and an incisive mouth which always looked as if it was just about to speak. He was of medium height, stocky but lean, with lively gestures and a jerky step; vehement in speech, interminable when expounding his opinions, and not much disposed to give ground in an argument. In his studio in the rue Lepic, Vincent had impressed Bernard with the many boxes of work, including a painting of the *Moulin de la Galette* with its spiky sails outlined against the sky, which Vincent assured him would prove to be of enduring value; images of peasants in hovels, sharing primitive meals, people with not a *sou* to bless themselves with in a picture called *The Potato Eaters*.

Vincent found no lack of subject-matter in and around Montmartre and along the banks of the Seine. From his repeated visits to the Louvre he claimed to have memorized all the greatest works of art. He became an admirer of Bernard's work and urged Theo to buy particular examples for his gallery. Vincent's other close friend from the days of Cormon's Academy, Toulouse-Lautrec, painted a vivid pastel and watercolour study of him which catches the vibrant alertness of his prematurely greying head.

Three months after Vincent arrived in Paris, he and Theo moved into an apartment on the third floor of a residential building in Montmartre, close to the Boulevard Clichy, with rooms commanding a fine view of the city. They lived there in some comfort surrounded mostly by Theo's furniture, books and paintings. Vincent seemed happy. Theo wrote home that Vincent was in good spirits and beginning to make his mark on the art world. Not to alarm his mother, he failed to mention that Vincent had lately undergone drastic dental surgery, which had further ravaged his facial appearance. Vincent's demands on Theo remained as pressing as ever and his social behaviour continued to be unpredictable. He was growing ever closer to his friend Emile Bernard and the two would discuss one another's work with Vincent as vehement and as stubborn in his opinions as ever. Bernard admired the work Vincent was producing in Paris but was particularly affected by the dour

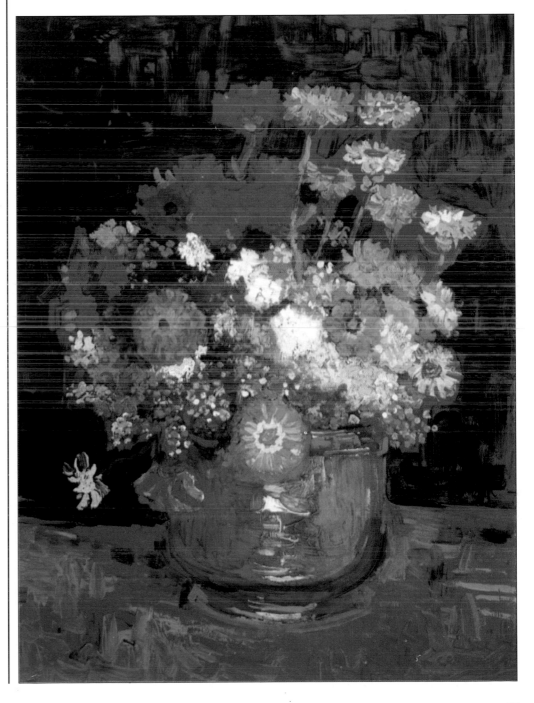

PARIS: *parks, gardens and the Seine*

solemnity of *The Potato Eaters* – a masterpiece inspired by a very different world.

Soon after leaving Cormon's Academy, Vincent painted two versions of the view from his studio window. One of these he now presented to Lautrec, who was living in the rue Tourlaque. The second version he gave to Suzanne Valadon, a fellow-painter whose portrait he had recently painted. She gives a vivid account of Vincent visiting her one Sunday, arriving with a strange-looking holdall out of which tumbled a number of canvases which dumbfounded the assembled company. No one was prepared to make the first comment. After a short pause, Vincent picked them all up again and, moving 'as awkward as a rusty automaton', as one of those present put it, and still without uttering a word, walked out again. Suzanne Valadon, furious with her guests, was gradually to adopt elements of Vincent's style, with notable results.

Vincent in his roamings discovered Montmartre, where he painted the park and gardens from various viewpoints, as well as the Moulin de la Galette. He also explored the suburbs and outlying districts of the city – Asnières, Joinville, Châtou – as well as Seurat's painting-ground – La Grande Jatte. Bernard, a frequent visitor, described how Vincent would walk the streets with a large canvas on his back, which he would unpack, divide into smaller sections, and work on in sequence. By evening, from all accounts, these would be covered with images of everything that had passed before his eyes, from boats on the Seine to floating restaurants with coloured awnings; odd corners of gardens, houses with *For Sale* notices – all, in Bernard's words, 'lifted with the end of his brush and stolen from the fleeting hour.'

The official Salon of the time was dominated by a new avant-garde led by Puvis de Chavannes, a precursor of the Symbolist movement and a leading decorative artist of his day, and by the Pointillists, headed by Georges Seurat

PARIS: *a dawning of the light*

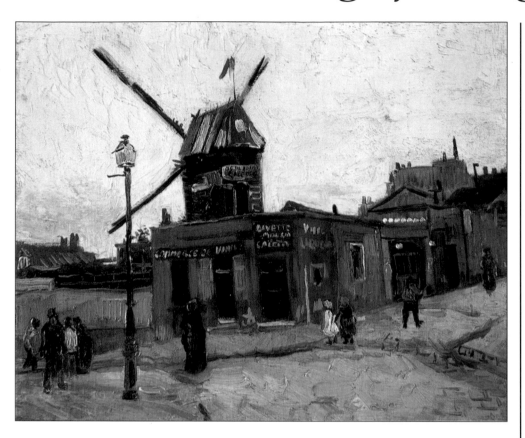

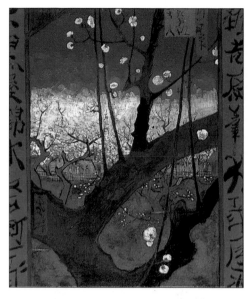

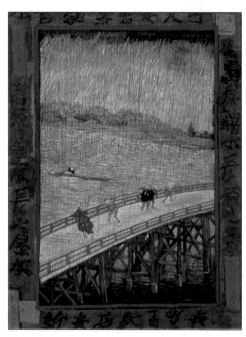

and Paul Signac. Vincent had seen no Impressionist paintings before his arrival in Paris but was beginning to share their widening choice of subject-matter, liberated use of colour and adventurous brushwork. However, his two paintings of *Montmartre: Quarry*, executed in the autumn of 1886, display no specifically Impressionist influence, and his brushwork remains typical of the work done in Holland a few years earlier.

His lodgings in Montmartre brought him into close contact with the entire gamut of Impressionist thought, though it is uncertain if he was fully aware of this at the time. In the summer of 1886 he painted a series of flower subjects, seeking – in his own words – oppositions of blue with orange, red and green, yellow and violet, looking for broken and neutral colours to harmonize what he called 'brutal extremes'. The impulse at this period came from Monticelli, a Provençal artist whose work Vincent admired scarcely less fervently than that of Delacroix. To him, colour was synonymous with feeling; his palette was at the command of his emotions.

Paris did have one other memorable experience to offer; his liaison with Agostina Segatori, proprietress of a café known as Le Tambourin. She had been an artist's model – Corot and Degas had both painted her – and Vincent was widely believed to have had an affair with her. He painted her posed at a table in her café, clad in vaguely ethnic garb, cigarette burning between her fingers – a symbol of bohemian liberation. The round table, the man-sized beer glass and the general atmosphere of *laissez-faire* gives the work an abiding fascination.

Initially, the Parisian ambience had a mellowing effect on Vincent's tortured spirit. Though he did not expect a swift change in his fortunes, he was not unduly depressed. He had substantially lightened his palette in response to the vividly natural style of the Impressionists. Their influence had gradually caught up with him in his everyday contact with exponents of the form. Four dealers had expressed interest in his own work, and Theo kept a number of examples in stock at prices in the region of 50 francs.

PREVIOUS PAGES
Bowl of Flowers, 1886

TOP LEFT
Le Moulin de la Galette, 1886

TOP RIGHT
Japonaiserie: Flowering Plum Tree, 1887

ABOVE
Japonaiserie: Bridge in the Rain, 1887

OPPOSITE
Père Tanguy, 1887-8

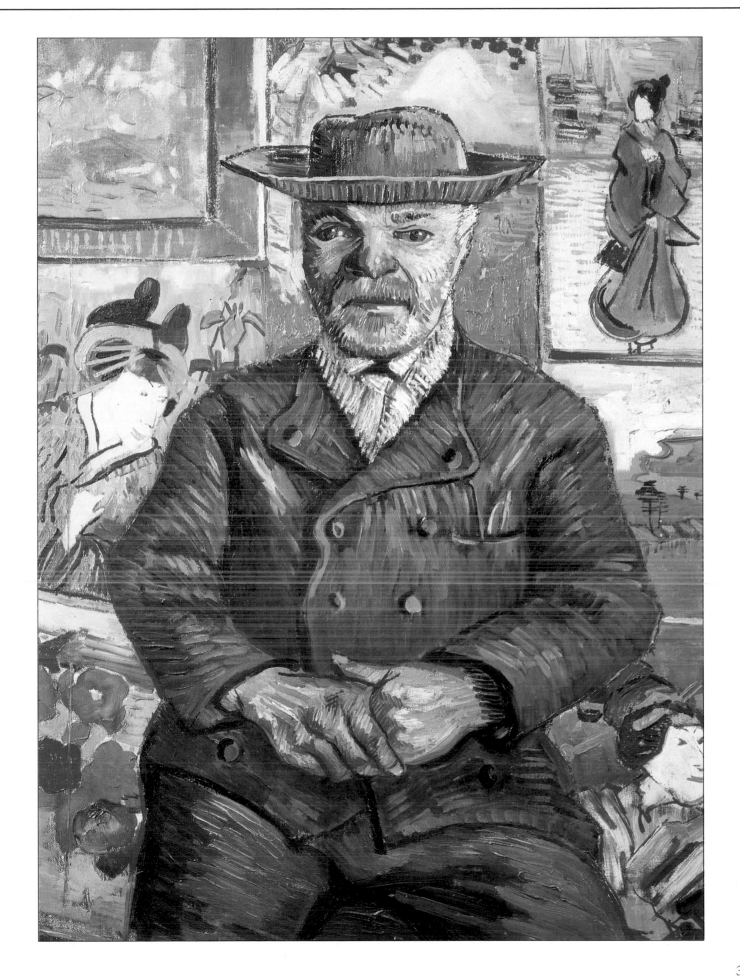

PARIS: *the tyranny of genius*

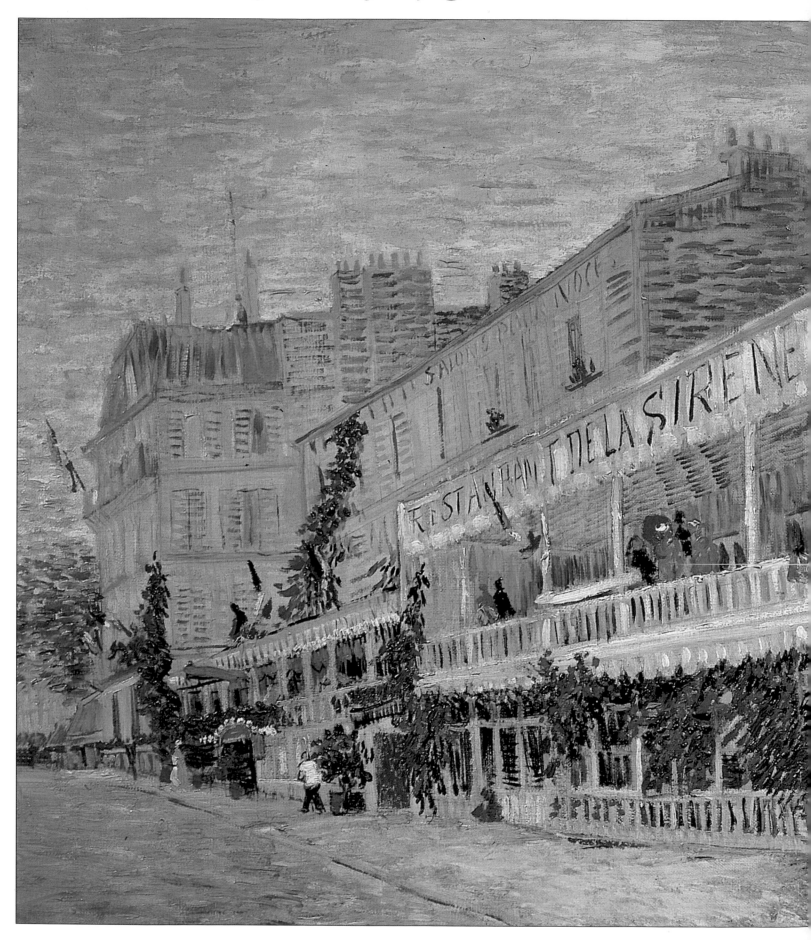

Vincent's true reward was the very air of Paris: it helped to clear his brain.

He never involved himself in the commercial scene: this he left to his brother. He was beginning to feel the remorseless passage of time: he was now 35, felt a good deal older, and was losing any desire he might once have had for a wife and family. Theo's future would be quite different. If Theo were to fall in love and get married, he could easily be imagined living in a substantial country house like so many other dealers. Vincent began to see how an aura of prosperity could similarly help to advance an artist's career, but ruefully confessed to himself that this would never be his style. In Paris, as in other sophisticated

Theo began to complain that his home-life was becoming unbearable, that his friends had stopped visiting him because of Vincent's paranoid wranglings

cities of the world, nothing succeeded like success.

His circle of contacts in the art world gradually widened to include Gauguin, a celebrity at 36, noted for his contentious views on all matters connected with art. He was an admirer of Paul Cézanne, at that time a painter almost as obscure as Vincent. Gauguin took Vincent to places where artists gathered, such as the Nouvelle Athènes where conversation and exchange of ideas abounded. Gauguin was sure that if only he could learn to control his temper, Vincent would eventually make his mark. Paul Signac, who also came to know him at this time, described him in his ubiquitous workman's blues, sleeves dotted with paint, wildly gesticulating and brandishing his latest canvas which he would prop against a wall and invite passersby to make critical comments. Vincent's style was still in a process of evolution. Now he loaded his brush more heavily with pigment, laying on bright colours side by side with pale ones.

Vincent and Theo had never lived before in such cramped conditions and the strain was beginning to tell when Theo, returning from a long day at the gallery, would be instantly pounced upon by his brother and subjected to a remorseless torrent of pent-up rhetoric. Neither was there any let-up when Theo retired to bed, for Vincent would still be there in the early hours, endlessly going over old ground – the state of the arts, the miseries of a painter's life, the lack of interest in his work and theories. Theo began to complain that his home-life was becoming unbearable, that his friends had stopped visiting him because of Vincent's paranoid wranglings and the state of chaos he created around him.

Though Vincent was forever threatening to go and live on his own, he made no effort to do so. It seemed to Theo as if he were two different people, one the marvellously gifted painter and the other a cold-hearted tyrant, constantly switching from one extreme to another until Theo felt he could bear it no longer.

It was ironic that it was Vincent who initiated the final split following a serious breakdown which prostrated Theo for weeks. Even so, the strong bond between the brothers could not be entirely severed. Theo eventually returned to work. Vincent resumed his wanderings around Paris and painted a vivid still-life which he inscribed 'To my brother Theo.' On the verge of a nervous breakdown himself, he made the most fateful decision of his life. He made it known that he was leaving Paris. On 20 February 1888 he was on the train to Arles.

LEFT
Restaurant de la Sirène at Asnières, 1887

41

SOUTH OF FRANCE: *the journey to Arles*

It was an inspired decision. But why Arles? Vincent is not known to have hankered after Provence. The likeliest candidate who may have been responsible for planting this idea in his mind is Toulouse-Lautrec, for whom Vincent had a high regard. His decision was no doubt coloured by the assumption that anyone from such an old and aristocratic family as Lautrec's must not only be well-off and well-educated, but also knew their way around.

While in Paris, Vincent had been trying to gather a group of contemporary painters into a co-operative of sorts – a notion of no appeal whatsoever to Lautrec even though he knew Vincent was relying on him for practical support. He may have had an ulterior motive for encouraging Vincent to leave Paris, for if he were to go, his tiresome ideas would go with him. But maybe Vincent had his own longing to follow the sun to the south of France. Perhaps he longed for a different light from the one in which he had grown up. He was anxious to discover an otherworldly landscape which would match the achievement of the Japanese masters. His other motive for seeking the sun was the state of his health. He left Paris, as he said later, sick at heart and in body, locked in his own misery.

His first sight of Arles, as he stepped from the train, was an avenue of plane-trees. Three weeks later, it became the theme of his first painting, embracing the public gardens, a weeping willow and an expanse of grass. He found his first lodgings at a small hotel, of which he duly made a painting. There is no sign of the snow which, unexpectedly, met him as he descended from the train.

Vincent had not been displeased with this unseasonal greeting: inevitably, the snow at once put him in

Couples in the Voyer d'Argenson Park at Asnières, 1887

42

ARLES: *dreams of a painters' brotherhood*

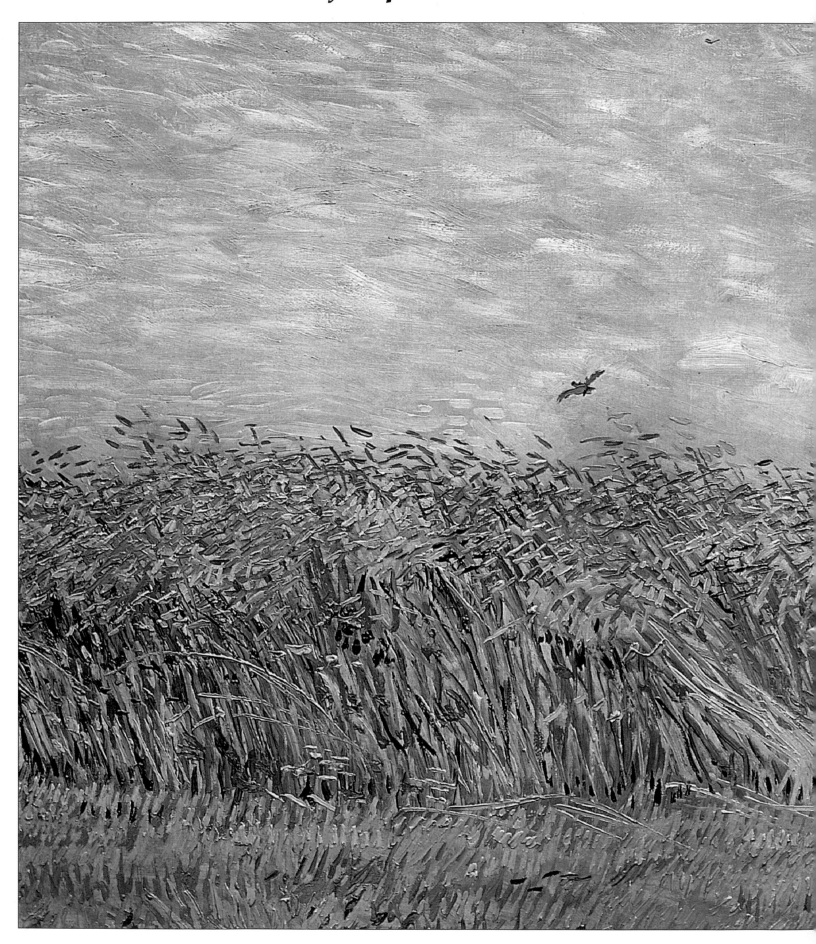

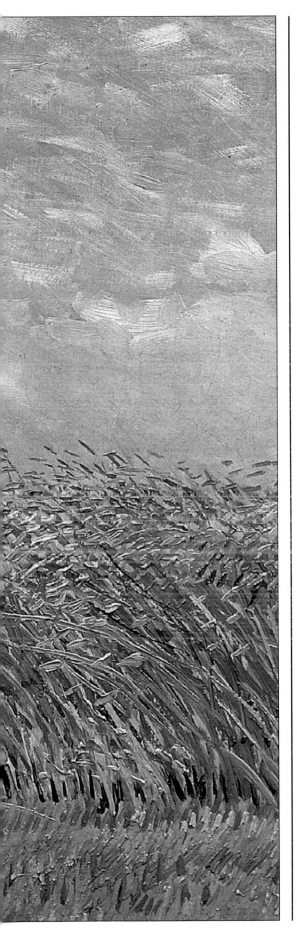

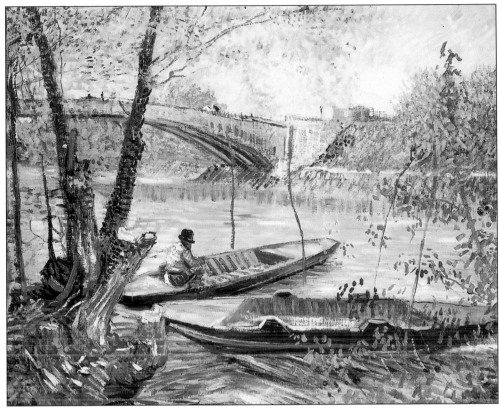

mind of winter scenes in Japanese prints. The snow-bound landscape painted soon after his arrival in Arles, two church towers silhouetted against the horizon, and a companion snow-piece, are bathed in an exotic light. His excitement at discovering Arles revived the idea of a painter's co-operative, a brotherhood of mutually sympathetic interests. In Paris, he had tirelessly promoted the enterprise among all kinds of painters who might be prepared to listen.

The snow passed, an early spring followed, and the fruit trees exploded into blossom. By the beginning of March the orchards were clad in white, pink and mauve. Vincent discovered that he no longer needed to pore over his Japanese prints. He told Theo that he felt he was in Japan already: he had only to open his eyes and paint whatever was in front of him; an immediate response to an emotional experience, deeply personal rather than objective or analytical. He continued to paint with a vivacity and fluency rarely seen in his earlier work. He sent examples to his friends in Paris, who reciprocated in kind, so

that his room became a jumbled gallery of unframed works by painters he admired, notably Bernard and Gauguin. Never, as a painter, had he enjoyed such a sense of comradeship. This unlooked-for satisfaction, and sense of affinity with the Japanese masters he so admired, enhanced the emotional content of his work, enlivened his choice of colour and permeated his sense of design.

After years of living in other people's spare rooms, cramming himself and his belongings into makeshift lodgings, he was delighted to have a real roof over his head, sharing with no one; spared the complaints of unsympathetic landlords. His hotel room at Arles was a stopgap and he soon found an alternative: the four-roomed wing of a small house in the Place Lamartine. As he had no bed, or money with which to buy one, his new abode was no

LEFT
Wheat Field with a Lark, 1887

ABOVE
Fishing in the Spring, Pont de Clichy, 1887

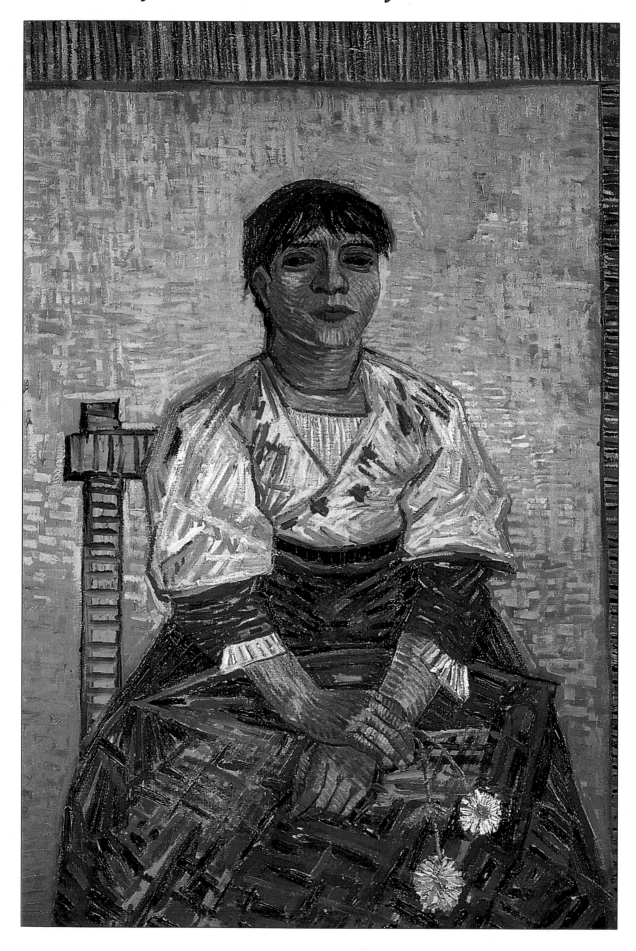

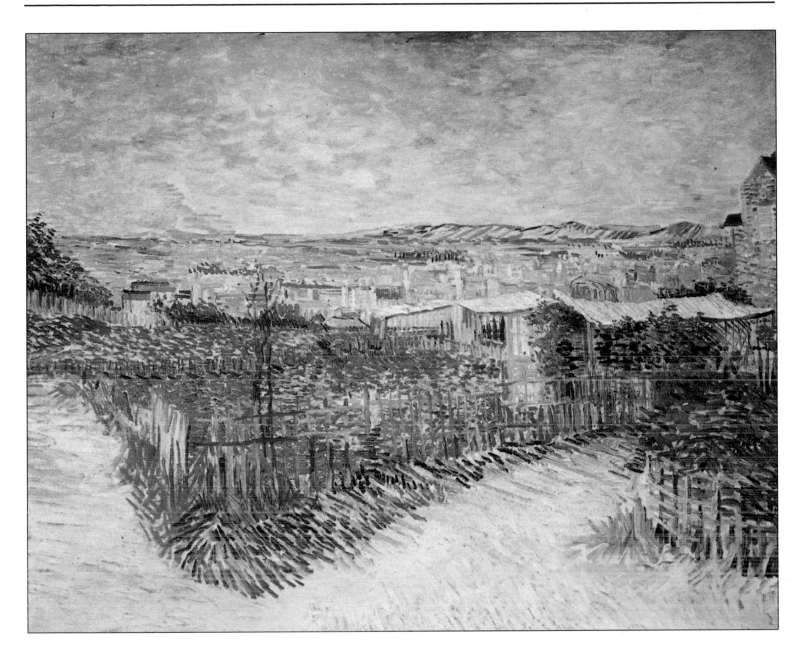

more comfortable than the sort of places to which he had previously been accustomed. Whatever its shortcomings, however, he gradually began to furnish it with oddments and the simple necessities. He looked forward to receiving visitors from Paris, most notably Gauguin, to share it all with him. The paucity of his possessions, to which he was gradually adding, is apparent in his *Still Life with Coffee Pot,* painted in May 1888, just as Arles was feeling the first breath of summer. The fruit and domestic objects are grouped in an arrangement that speaks of home.

Before long, Vincent was carting crates of paintings down to the railway station, addressed to Theo in Paris. By then he was quite settled in and tackling outdoor subjects within easy reach, such as the Dutch-style drawbridge with a small cart crossing it, outlined against a blue sky; banks, orange-coloured with green grass; a group of washer-women in smocks and multi-coloured caps.

As late spring turned to summer and almonds were beginning to form on trees only recently a riot of colour, Vincent wrote to Theo that he could very easily imagine that he was living in Japan. He described his life as too delightful not to share – he longed for

LEFT
The Italian Woman,
(Agostina Segatori), 1887

ABOVE
The Gardens of Montmartre, 1887

47

ARLES: *figure in a landscape*

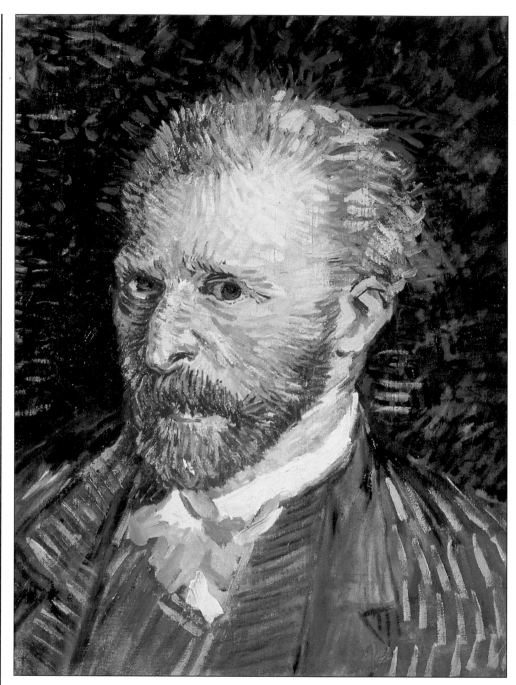

comradeship, especially when there was now so much more in his life. Over and over again his thoughts turned to Bernard and Lautrec, the first friends he had made in Paris, and probably the best. Bernard sent him some sonnets he had lately written which Vincent found time to discuss in detail. Was it not true, he asked, that saying something well, as poets do, was as interesting as painting? Meanwhile, he informed his friends that he was at work on no fewer than nine studies painted from his terrace – white, pink, white-blue, greyish-pink, and green. His output doubled and re-doubled. In a note to Bernard, accompanying one of his orchard scenes, he pointed out the colours he had used – a patch of green, lilac for the soil, orange roofs – adding that he was at that moment working on several more such subjects.

He suggested that Theo, who had been unwell, would benefit from a visit. Wouldn't he like to come down? He himself had given up drink and cut down his smoking after coming to the conclusion that the best régime was a sensible life; cold water, fresh air, simple food, a decent bed, and no women. He described the women of Arles as 'very beautiful, like a Fragonard, or a Renoir.' But, he wondered, would there ever be a

ABOVE LEFT
Vincent's portrait reproduced on the side of a marquee

ABOVE
Self-Portrait, 1887

RIGHT
Avenue of Plane Trees
Near Arles Station, 1888

painter who would be to figure-painting what Monet already was to landscape? This remark is a good indication of the great Impressionist's standing among painters of Vincent's generation working in the 1880s.

He can never have been in such buoyant spirits before. With brief exceptions, his life had been a painful struggle, dogged by false starts and disappointments. The overwhelming colour that now poured from the southern landscape inspired him with a rhapsodic vigour that he had never

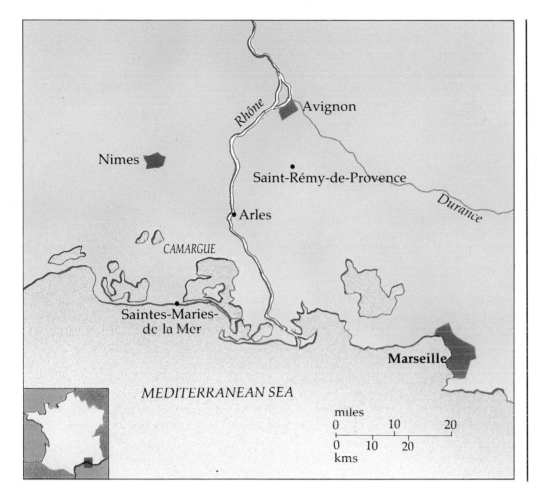

Vincent left a vivid record of other subjects he had painted since his arrival in Arles. They include a still-life with blue-enamelled coffee-pot; a vivid blue cup and saucer; a milk jug with cobalt and white checks; a cup with orange and blue patterns; a blue majolica jug decorated with green, brown and pink flowers against a yellow background adding: 'Oh, and another still-life, lemons in a basket against a yellow background.' He described the little town itself, its red roofs and tower visible from his bedroom, surrounded by meadows blooming with wild flowers, and in

before experienced, sharpening his responses and fuelling all the latent energy which he had largely wasted in his youth. He described colour in a painting as like enthusiasm for life, a personal revelation which he could not wait to share with the rest of the world.

At one time he would have welcomed some form of recognition from the Church authorities whose duty it was to console those who laboured for their bread. Though he had always shown a sure touch with the single subject – the toiling peasant, a hunched figure, a starkly perceived nude – these were still a statement of social conscience. In Arles, there was no such conflict. A flowering almond twig in a glass jar encapsulates the dignity of creation in simpler forms: the twig, though broken, has been rescued despite its humble appearance because it is of immeasurable value as an object of beauty.

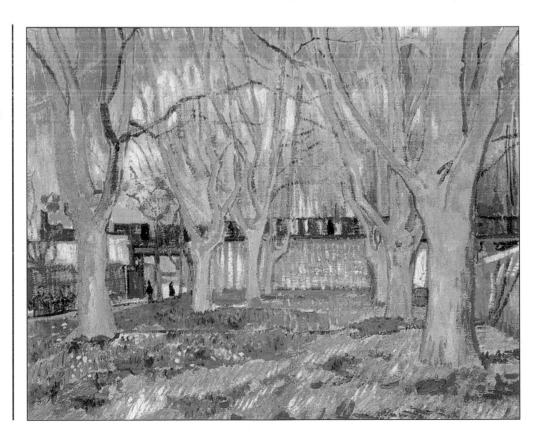

ARLES: *life in 'a house of light'*

the foreground a ditch full of violet irises. As for his house, La Maison Jaune (The Yellow House), he saw it as a 'house of light' for his longed-for brotherhood of painters, and his own room as a place of perfect rest. He decorated its walls in pale violet, the floors in a faded red, chairs and bed in chrome yellow, bed-clothes a lime green and the quilt blood red. The painting of the room does not exactly follow the original in every detail, and not everyone would consider its colours restful.

He now began to discover local features that delighted him, among them the drawbridge over the local canal, which reminded him of Holland. His excitement by the purity of the Provençal light, which enhanced natural colours to a degree undreamt of in Holland, is shown in the vigour with which the little scene is brought to life. He made several versions of the market-gardens at Arles overlooking the Crau. 'In this flat landscape,' he told Bernard, 'there is nothing but infinity, eternity – even more beautiful than the sea, because it is inhabited.'

When the sunflowers came into bloom, Vincent decorated his studio with them in honour of Gauguin's visit, gathering them at sunrise to preserve their short-lived glory. His thoughts returned to Millet and to the symbolism inherent in the sowing of seed. 'What does it matter if we humans are not sown in the earth to germinate? In the end we are ground between millstones to be turned into bread.'

Vincent's first trip from Arles, in June 1888, was to Saintes-Maries-de-la-Mer, which involved a lengthy journey across the marshy plain of the Camargue. He was too late for the annual concourse of gypsies for which the town was famous but was delighted by the local women, whom he compared to the slender, serene young virgins of Cimabue and Giotto. He was struck by the grace and charm of the fishing-boats – they reminded him of flowers, green, red and blue, scattered at the water's edge. Vincent's painting, redolent of Japanese art, brings the rich blue of the sky into vivid apposition to the startling orange sand against the ink-blue of the

BELOW
Still Life: Blue Enamel Coffee Pot, Earthenware and Fruit, 1888

RIGHT
Drawbridge with Carriage, 1888

BELOW RIGHT
The bridge as it appears today

Mediterranean. It was here that Vincent met an officer of the Zouaves, Paul-Eugène Milliet, whom he took as a pupil and immortalized in one of his most expressive portraits.

Vincent's foremost anxiety at this time, and it was as urgent as ever, was that Theo might no longer be able to help him out financially, owing to a crisis at Goupil's which threatened his brother's livelihood. Vincent also wished to stock up in order to have plenty of work to show Gauguin. Altogether, he was away three months, in which time he produced some of the most deeply-felt landscapes of his career.

Back in Arles, he lived the solitary life. He seemed to need no company but his own as he wandered around the streets and park by the Place Lamartine, setting up his easel away from curious eyes. His leisure activities he reserved for after dark, including his visits to bars and cafés. His masterly painting, *The Café Terrace on the Place du Forum*, is an example of how to paint the seemingly impossible. The subject is a night scene with no black in it, merely the shades and tones of a gas-lit terrace, a study in yellow and deep blue, which produces Vincent's familiar sour green to describe the empty table tops. It succeeds in creating an artificial glare from the gas lamps in contrast to the lustrous blues of nightfall. The glare of the lamps on the cobbled foreground achieves an illusion in describing their shape, through in reverse: the humped tops, which would be bright in gas-light, are painted as black hoops, so reversing the natural effect of light on the

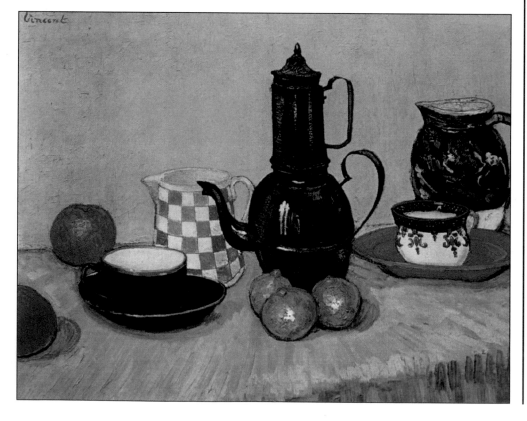

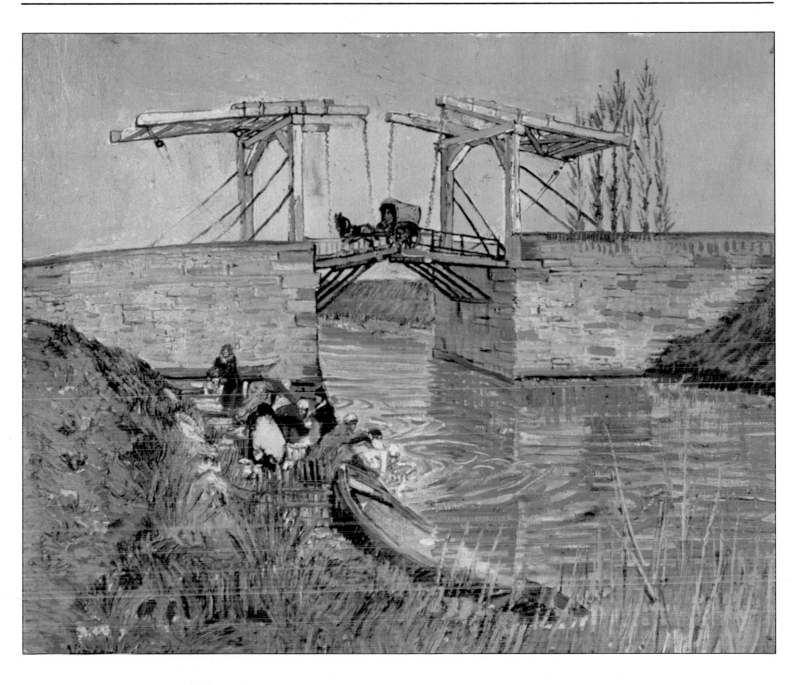

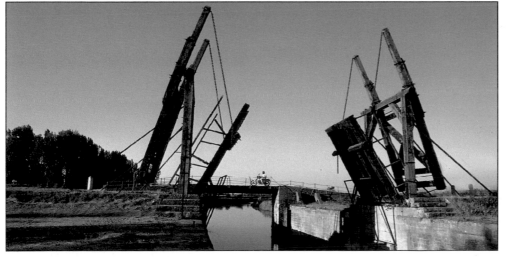

cobbles. Above, stars explode in puffs of light as if seen through narrowed eyes adjusting to the glare.

A revealing account of how Vincent came to paint *The Night Café* is included in a letter to Theo. He had spent three consecutive nights there, sleeping during the day. The painting, he said, was the 'most discordant' he had ever done. He saw the café as a faintly evil place where a man could ruin himself, go mad, or commit a crime. The new artificial gas lighting was not, to Vincent, an improvement. To his mind it was unnatural, producing sinister effects.

ARLES: *a dance to the music of Time*____

52

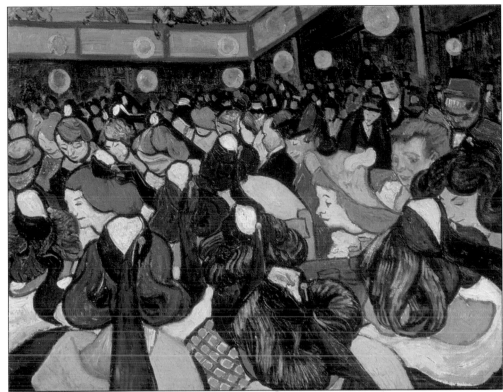

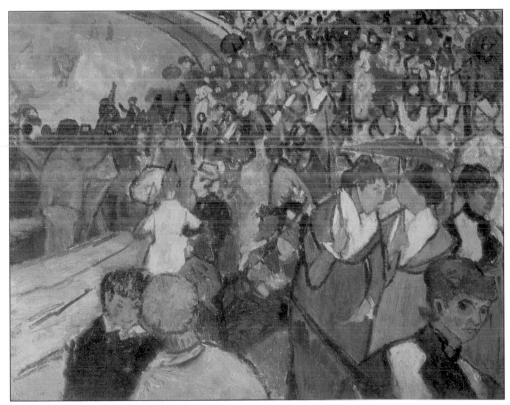

ARLES: *explosion of the heavens* _____

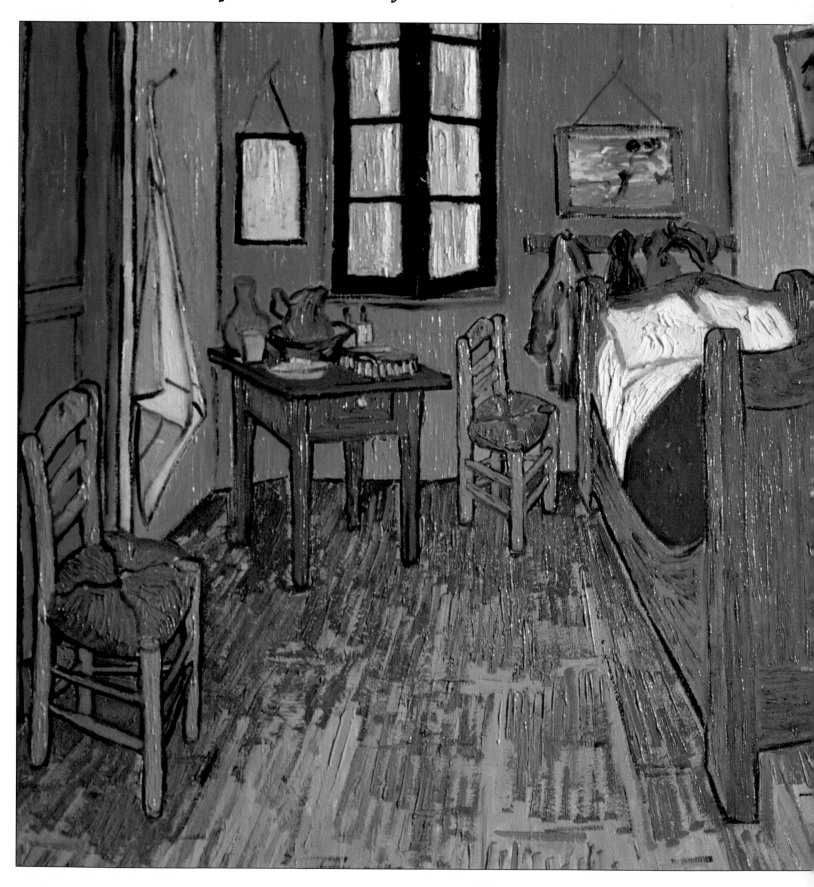

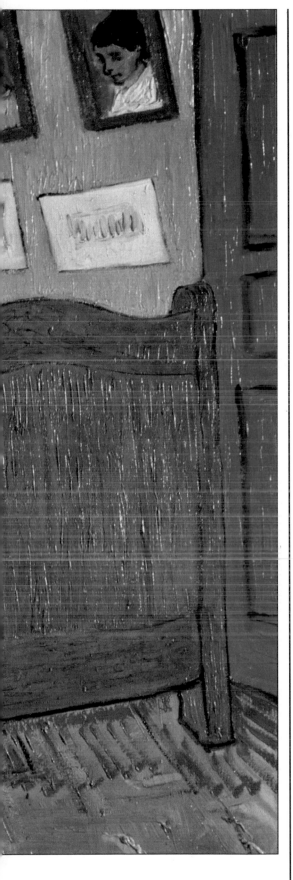

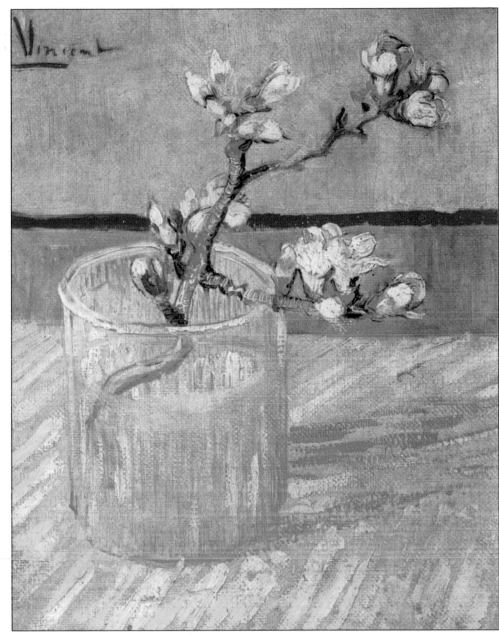

When he had finished *The Night Café*, Vincent gave it to the proprietor – he never wished to see it again.

Elsewhere, Vincent confessed his love of moonlight and the night sky with its myriad stars and how he was spiritually uplifted by the experience of painting them. He could imagine the heavens peopled by such luminaries as Newton, Copernicus, Galileo, Jesus, Buddha, Confucius and Socrates, and came to the conclusion that death, after all, might not be such a bitter ending to a painter's life. 'When I look at the stars,' he told Theo, 'I always start dreaming. Why, I

wonder, should the shining points of the heavens be less accessible to us than the black dots on a map of France?'

It was at this time that Vincent's godfather, Uncle Cent, who had done well out of the art business, died, leaving a will which excluded Vincent from any share of his fortune. Theo, on the other hand, was to receive proportionately more. He insisted on putting matters right by handing over the unexpected bonus to Vincent, who was now able to renovate his accommodation in Arles. He still believed that his ambition to turn his

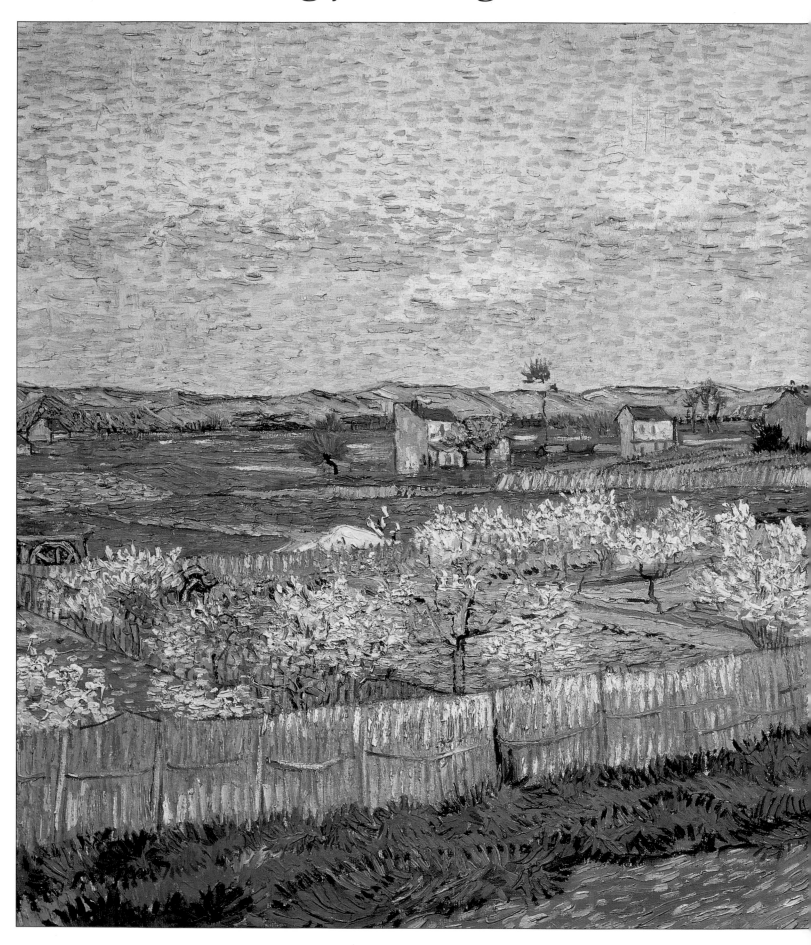

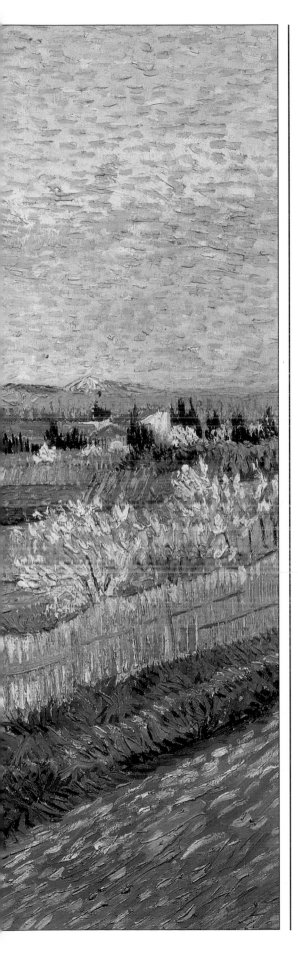

home into a centre for fine art, a co-operative of friends and equals, could be realized.

He painted a picture of The Yellow House, as if to advertise its imminent change of status, adding a steam train to the picture as an indication of its growing relevance in the modern world. He envisaged a ménage of painters living virtuous and productive lives under the aegis of a leader – ideally Gauguin, whose well-known atheism need not necessarily be a drawback given his predilection for crucifixion scenes. Vincent, in a sudden mood of depression, confided

Vincent did everything he could to make his home acceptable to Gauguin, from sleeping quarters to hand-painted pottery

to Theo that he would just as soon lock himself away in a monastery but for the fact that the potential brotherhood would require a communal home.

In a mood of mounting excitement he allowed his expectations to take flight. He did everything he could to make his home acceptable to the lordly Gauguin, providing comfortable sleeping quarters and hand-painted pottery. He envisaged the adjacent gardens as the sort of place where, in their time, Dante or Petrarch might have been pleased to take the air.

He even painted four versions of a work entitled *The Poet's Garden* for him. The *Sunflower* series brought golden light into the well-scrubbed room. Vincent started work on them each day at dawn, for fear the sumptuous blooms would wilt before he could finish painting them.

At this time Vincent was working at a phenomenal rate, so intensely that he painted without noticing the

passage of time, the brush strokes coming thick and fast, as fluently as words in a conversation or a letter. This helps to explain his rapid repetitions: no sooner had he put one finished canvas aside than he was starting a new one of the same subject. His near-duplicates are not efforts to get exactly what he wants, but impassioned renewals carrying the same emotional charge. His second, third or fourth study of an identical subject cannot be perceived as repetitious, since each contains its own driving force, the energy of optimism. Vincent did not look for fine weather or ingenious viewpoints. He tackled each subject head-on, much as the Impressionists had shown him. This became his way of seizing a moment and transforming it into something more substantial than a quick impression of the here and now, making no distinction between colour and line. Both, in a work by Van Gogh are inseparable.

He later confessed though, that a series of rapid sketches which he had consigned to Paris were all worked out in advance, so that if he were to be accused of working too hastily he was being somewhat misunderstood by his detractors. He was never himself a sketcher, any more so than were the Japanese masters whom he so admired. They were able to produce rapid drawings which were complete in themselves because their sensitivities were more highly developed than ours; they were simply more in touch with their emotions. The point where feeling and observation came together was, to him, the instant of artistic creation.

The *Sunflower* series was all for Gauguin. He and his fellow artists would live amid works of art. Vincent had been working in the olive groves, inspired by a work sent to him by Bernard depicting Christ on the Mount of Olives, but could see no reason why he should put a figure of Christ in his own picture. 'Our duty is

La Crau with Peach Trees in Blossom, 1889

ARLES: *a far cry from Pont-Aven*

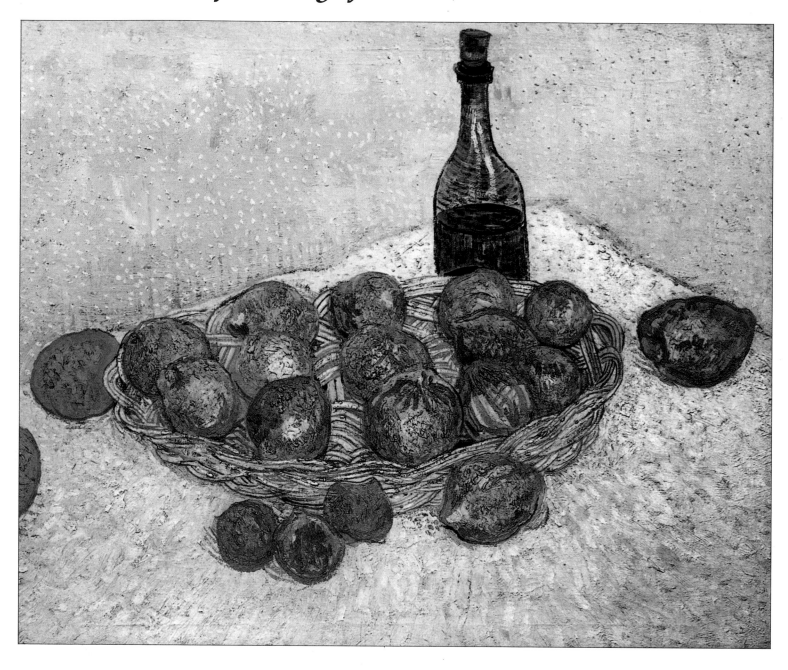

to think, not to dream,' he declared. Yet he, Vincent, had been brought up to believe every word of the Bible.

Gauguin, at this time, was beginning to have reservations about joining Vincent's community. A little Provençal town was a far cry from Pont-Aven. The thought of Arles had its attractions; he had been assured a position of absolute authority over the group – a natural decision given his talent and fame. Gauguin, by now, was living off Theo van Gogh's advances on his works, for which he was thankful. Whether he had any sense of obligation towards Theo or

ABOVE
Basket with Lemons, 1888

RIGHT
Seascape at Saintes-Maries, 1888

Vincent is doubtful. However, the next few weeks would tell.

Gauguin arrived at Arles on 23 October 1888, hoping for the best but fully prepared for the worst. He graciously accepted his role as something between artist-in-chief and honorary abbot. Vincent made great efforts to please him by imitating his style in his studies of the ancient burial ground, Les Alyscamps. He was even prepared to take a back seat for the time being so that Gauguin should have first choice of the range of new and exciting subjects with which the area abounded. Those who knew him

best would have been aware that Vincent's works marked, in symbolical terms, the progress of his unruly spirit. Some of these, on the other hand, are not so much stepping-stones as indications of a sensitive inner life. His paintings of two armchairs, his own and Gauguin's, both painted at Arles, suggest that his ambition to found a colony of painters was beginning to take shape. Unfortunately, Vincent soon began to realize that his friend, whom he worshipped, was bored with Arles, and far too self-centred to make much contribution to the project.

A message to Gauguin: 'Our duty is to think, not to dream'

Vincent's emotions veered wildly between hope and disappointment. His paintings of two chairs (page 65) are metaphors for himself and his celebrated visitor. Vincent's belongs in a kitchen, armless, on a tiled floor, offering nothing more significant than a pipe and a twist of tobacco. Gauguin's chair, on the other hand, is a shapely, cushioned one. It stands on a handsome carpet with a reading lamp close by; the book and candle are symbols of enlightenment.

In his memoirs, Gauguin was to remark that during his lifetime he had

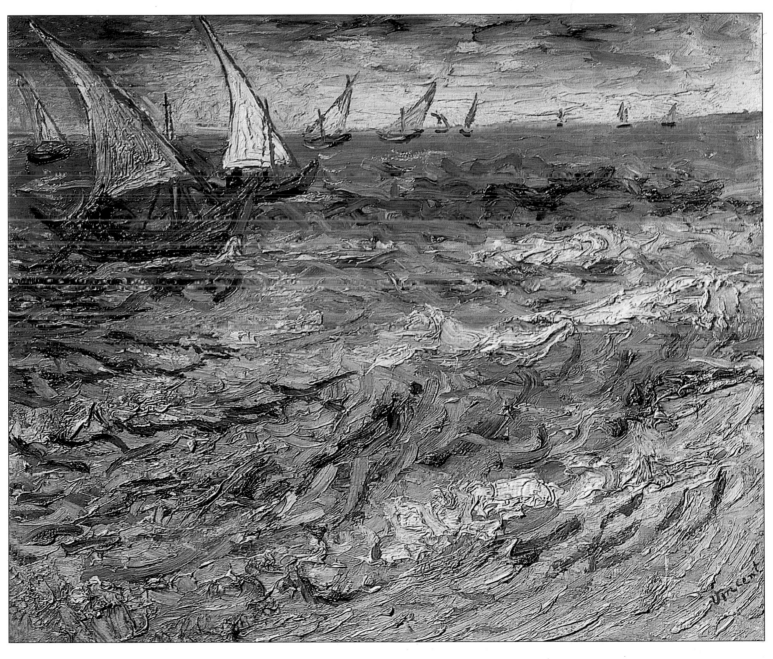

ARLES: *'farewell the tranquil mind'*

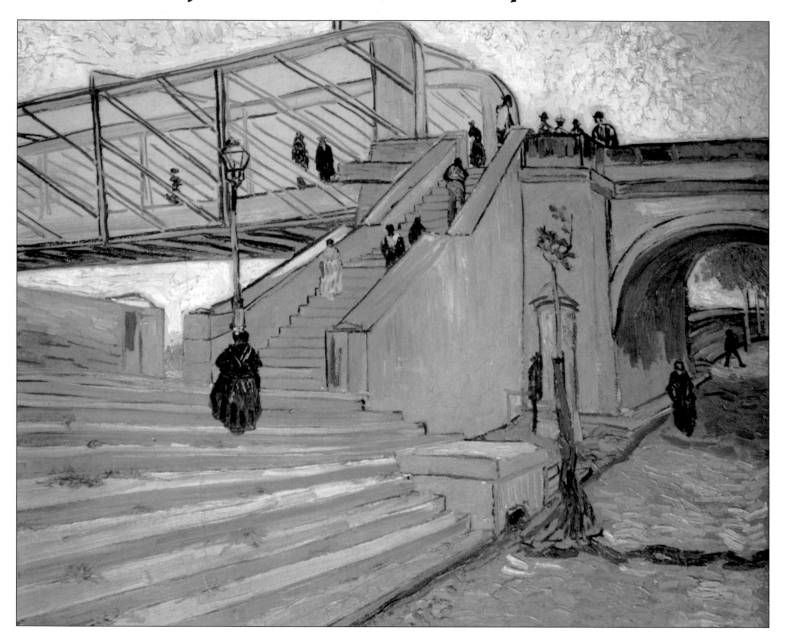

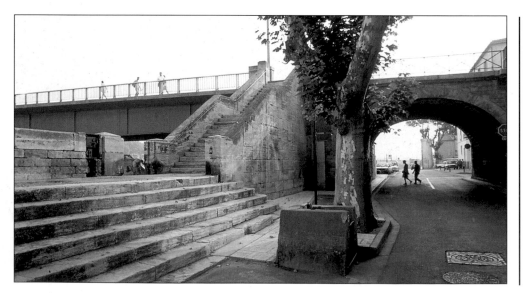

BELOW
The Trinquetaille Bridge, as it appears to day

RIGHT
The Café Terrace on the Place du Forum, Arles, at Night, 1888

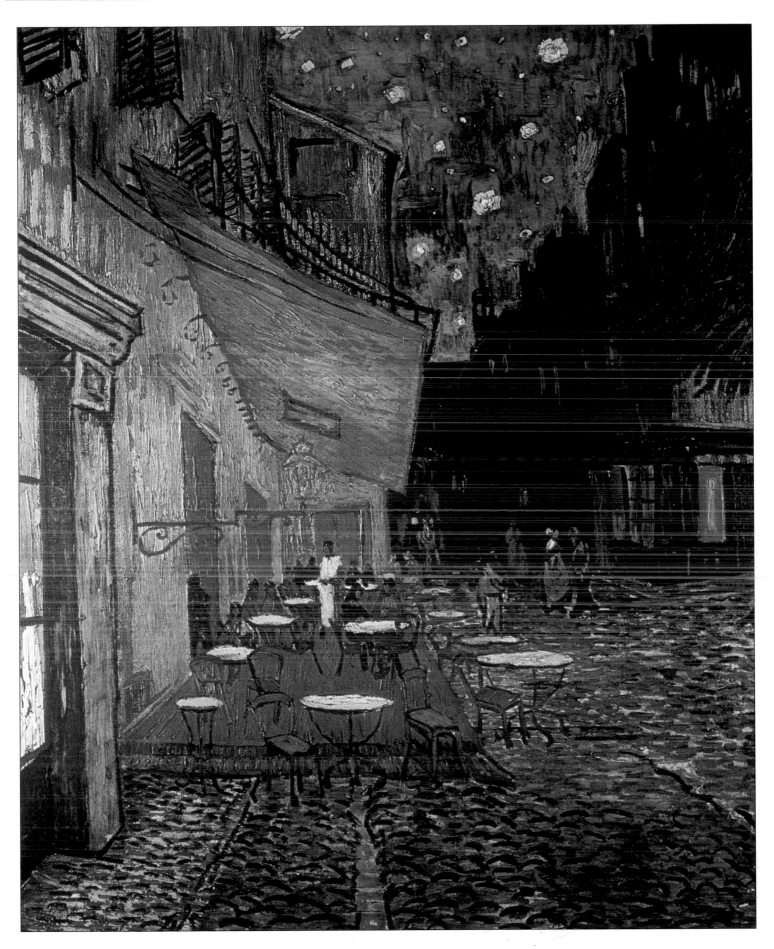

ARLES: *the coming of the dark*

held conversations with 'several men who afterwards went mad'. He could not match Vincent's inspirational flights into realms that he himself could never reach or even aspire to. One of these was Vincent's *Starry Night*, a supernatural vision full of wild gyrations, painted in late May 1889, by which time he was under medical supervision. This was no disturbed vision, however, but an idealized view of the heavens. It has been variously interpreted, and has been described as a celebration of the moment before daybreak when Venus, the morning star, rises towards the Milky Way.

It is filled with extraordinary power; the whirling shapes hurtle through the heavens with exaggerated force; the moon a lurid orange, sun-like; the emotion turbulent. Vincent admitted that the dramatic element in the work was 'exaggeration', the accentuated outlines being more appropriate to a woodcut than to a painting. He maintained that he was working closer to the expressive manner of Gauguin and Bernard who were indifferent to the portrayal of nature in exact forms. Theo, on perceiving Vincent's change of style and inclination towards the passionate imagery of Gauguin, warned him against too much drastic change for fear of losing 'the real feel' of the subject.

By October 1888, when Gauguin had been living with Vincent for a few months, their relationship began to deteriorate. So-called 'exaggerated tensions' culminated in a dramatic breakdown leading to self-mutilation when Vincent took a razor to his left ear after allegedly attacking Gauguin. The legendary sequel was Vincent's flight to the local brothel bearing the severed ear-lobe, which he presented to one of the prostitutes. Gauguin quickly departed. Vincent was discovered the next morning and taken to hospital for treatment. Theo hurried down to be with him.

A combination of epilepsy, dipsomania and schizophrenia were thought to be the cause of his outburst. Gauguin was later to receive a

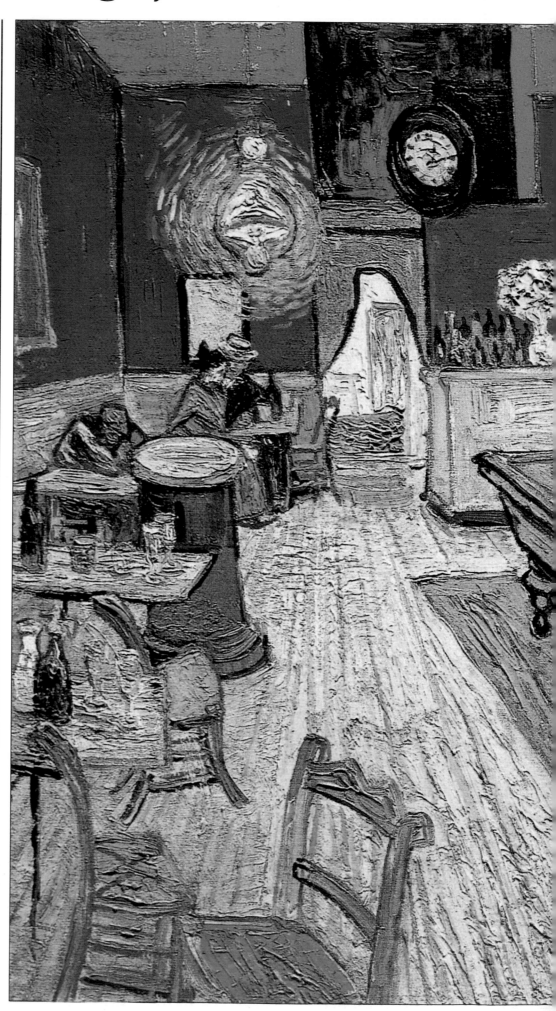

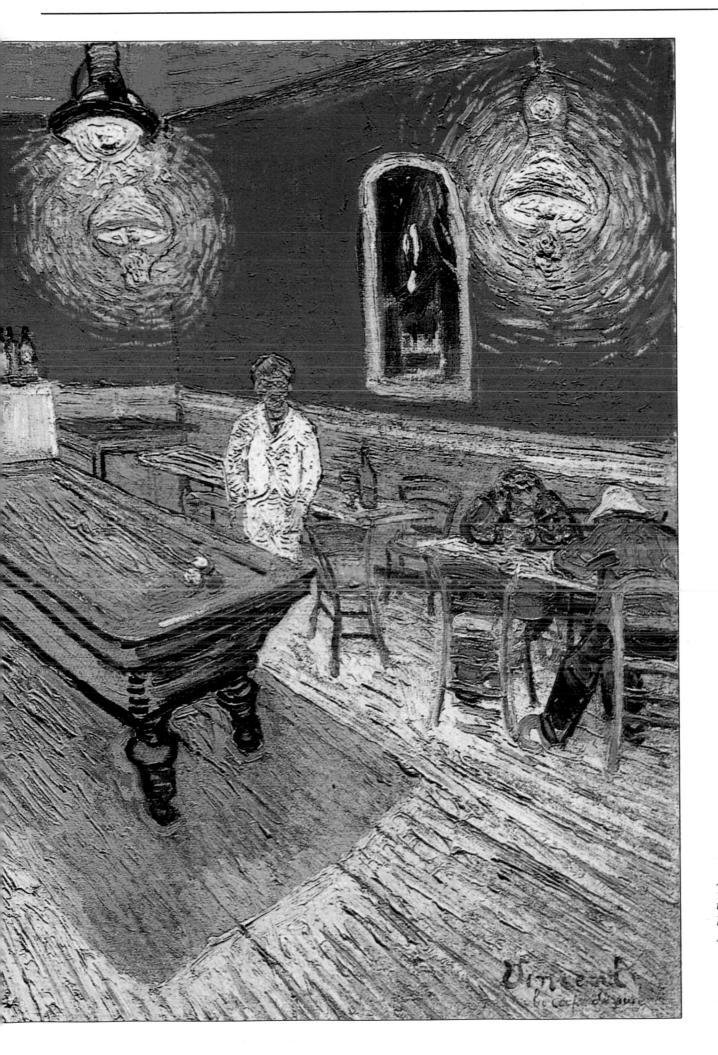

The Night Café in the Place Lamartine in Arles, 1888

SAINT-REMY: *images of the inner man*

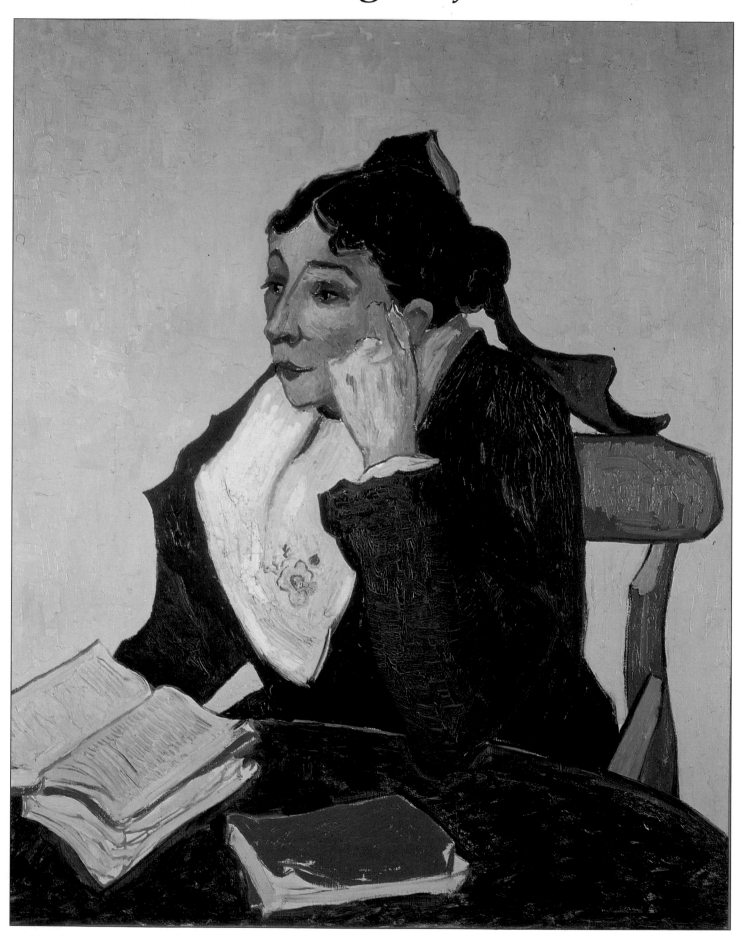

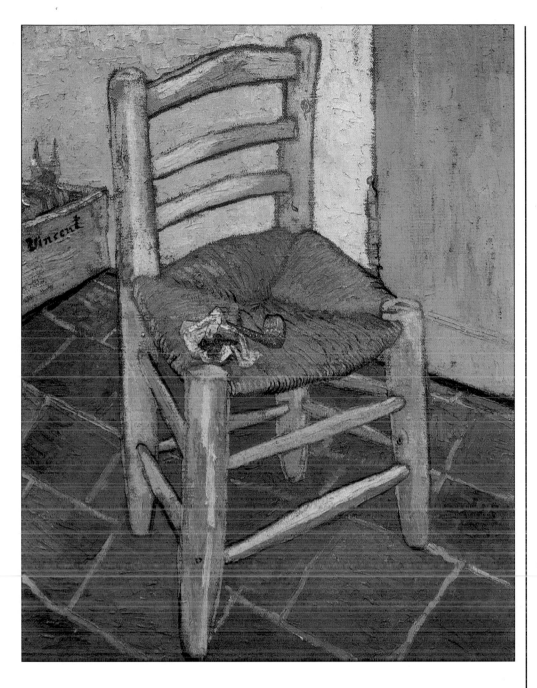

not as a madman but as the brother you know. The Commissioner of Police has given orders to shut me up again. Here I am in a cell under lock and key and with keepers, without any guilt being proved against me.' The police closed up The Yellow House and it was only Theo's support that prevented Vincent from taking his own life.

> 'I write to you not as a madman but as the brother you know...I am in a cell under lock and key, with keepers'

touching letter form Vincent re-affirming his 'very deep and sincere friendship'.

Discharged, and with his wounded ear in bandages, Vincent resumed painting, assuring his family that there would be nothing further the matter with him for 'a long time'. He painted his doctor, Félix Rey, before returning to The Yellow House. The people there fled at the sight of him; a few threatened him with violence. His neighbours petitioned the mayor to ensure that he was safely confined. Vincent wrote to Theo: 'I write to you

LEFT
L'Arlésienne:
Madame Ginoux with Books, 1888

ABOVE LEFT
Vincent's Chair with His Pipe, 1888

ABOVE RIGHT
Paul Gauguin's Armchair, 1888

Vincent, beginning to sense his own deterioration, voluntarily entered the mental institution at Saint-Rémy-de-Provence – though he considered it fairer that men such as he should be drafted into the Foreign Legion. When Theo's young wife suggested that he might be in better hands with them in Paris, Theo explained the difficulties of having his brother under their roof, with his unruly manners and total disregard for social convention. His closest friends had found him

ARLES: *torture of the inner faith*

difficult to get along with, even before this present episode. As for Paris, Vincent himself made it clear that, for him, the place was already something of a morgue, given the number of people he had known who had passed away.

Theo knew that the best therapy Vincent could be offered was the facility to paint. By now, Vincent had come to accept that his dream of a brotherhood of artists was at an end.

Theo entreated the superintendent of the asylum at Saint-Rémy to allow Vincent to set up his easel and paint out of doors. The local pastor, Frédéric Salles, had also been persuaded to accompany them prior to Vincent's

formal admission. He was given a relatively comfortable room and permission to paint in the grounds when so inclined. Soon he was deemed safe to be left unsupervised. By now there was general agreement that one of his more treatable conditions was epilepsy; the treatment being, at that time, two long, miserable baths a day. Vincent gradually began to feel that his condition might not be incurable. The asylum itself was bearable: there was a general room where he and his fellow inmates could sit, as he put it, like passengers in some third-class waiting room.

A last view of Arles, in May 1889, shows an orchard of blossoming peach trees with the little town beyond. It was painted when this beloved landscape was all but lost to Vincent with the spectre of the asylum looming. A few weeks after painting this work, he was gone, shunned by the townsfolk as a menace who deserved to be put away. This opinion was shared by the authorities, who issued a detention order on the people's behalf. The doors closed behind him on 8 May 1889.

LEFT
Two Cut Sunflowers, 1887

BELOW
Self-Portrait with Bandaged Ear, 1889

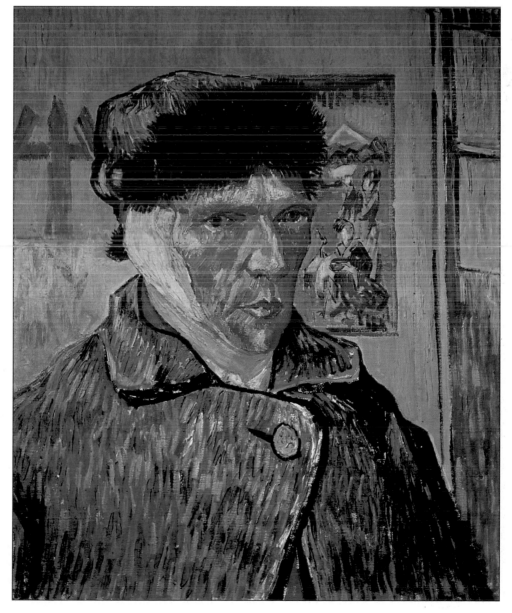

SAINT-REMY: *homage to fellow spirits*

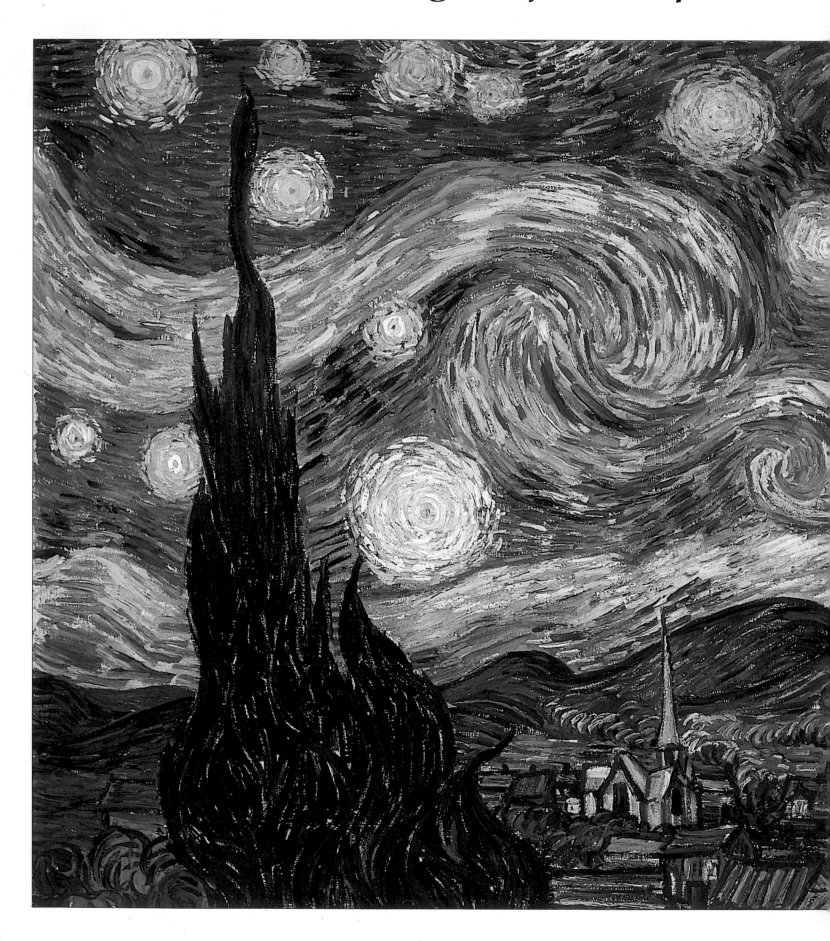

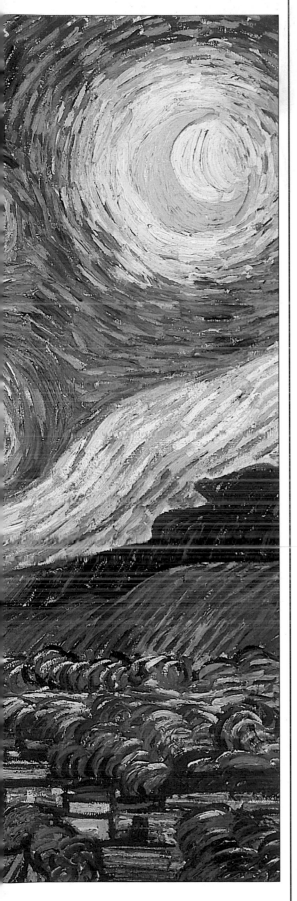

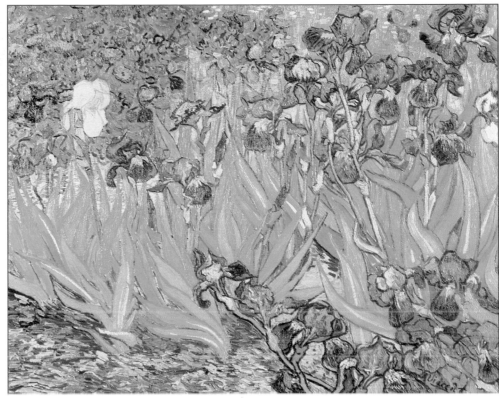

After a month at Saint-Rémy, Vincent was allowed to stray further afield with a guard for company. A feature of the work produced at this time is the crowded nature of the canvases, as if he were seizing every last inch of the space allowed him. He now saw a new beauty in the poplars, which reminded him of Egyptian obelisks. He would have liked to paint them in a similar fashion to the sunflowers of Gauguin's arrival. He invested his swirling summer skies with the same hectic energy as his starry nights. Theo recognized in these works a new torturing of forms as Vincent strained to convey an extra intensity of symbolism. His heightened emotions at this time were accentuated even more when Theo passed on to him the news that his wife, Jo, was expecting a child, and that they intended, if it was a boy, to call him Vincent.

One of his last self-portraits, in which he is posed holding a palette, shows Vincent gaunt but undefeated, his gaze a piercing blue. In Paris, meanwhile, his star was in the ascendant, following the impact of his work at an important exhibition of paintings by the XX (Les Vingt) group, who had also persuaded the reclusive Cézanne to take part. Of his own work, Vincent had chosen two of the *Sunflower* series, *Orchard in Blossom with View of Arles, Wheat Field with Reaper at Sunrise,* and *The Red Vineyard.* Theo was faintly alarmed at Vincent's sudden switch to what he recognized as something approaching the style of Gauguin, rather than what he still saw as Vincent's unique revelation of the true meaning of things.

No painter since Rembrandt had so clinically examined his own appearance as Vincent, treating it to the same intense scrutiny that he bestowed on all his subjects, whether they be lumps of clay or whirling skies. There is a particularly disturbing quality in the famous 'blue' self-portrait painted towards the end of his

LEFT
Starry Night, 1889

ABOVE
Irises, 1889

SAINT-REMY: *variations on a theme*

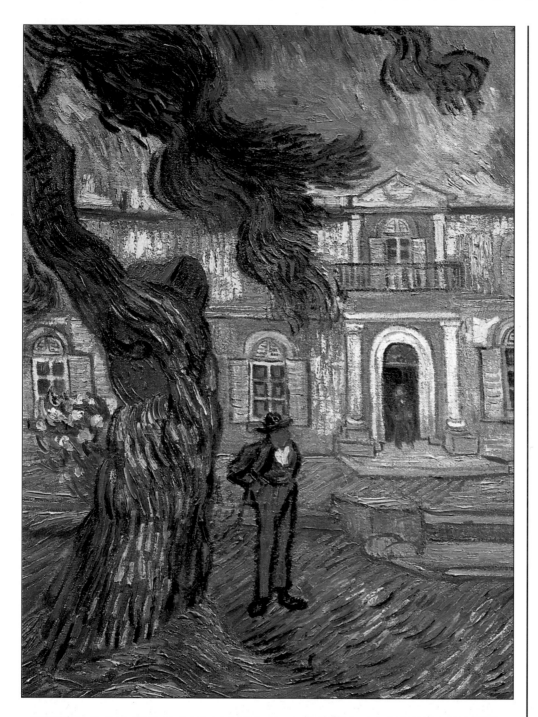

time at Saint-Rémy. It possesses the same stubborn intensity that is to be found in nearly all his self-portraits but is suffused, on this occasion, by the inspired use of a palette of light blue, applied to every area but the face and hair. His self-knowledge, the harsh suspicion with which he regards his reflection, elevates the painting to the realms of Rembrandt.

His turbulent stay at Saint-Rémy put him out of action for a whole summer, but by the autumn he was deemed safe to be allowed to paint outside in the company of a warden. His palette was sombre but his feeling for composition and dramatic impact was as sure as ever. There is nothing of sunny Provence in his work at this time. Indeed, his palette is closer to his evocations of the mining areas of the Low Countries produced at the beginning of his career. But the sun came out for him in mid-summer, when he painted a bunch of irises in an earthenware pot against a yellow background, though with not quite the exuberance of earlier days. He comes closer to full-blooded excitement with his study, *Road with Cypress and Star*, executed shortly before his discharge.

Vincent now embarked on a series of studies: homage to the memory of painters whom he had admired over the years – Rembrandt, Delacroix, Daumier, and above all Millet, with his stoical rustic figures toiling away in scenes reminiscent of the Bible – subjects which Vincent knew mainly from lithographs or woodcuts. His variations on these themes, though faithful to the originals, embue them with a tenderness that is entirely personal. He was well aware of the thin line that divides sentiment from

ABOVE LEFT
Pine Tree with Figure in the Garden of Saint-Paul Hospital, St-Rémy, 1889

LEFT
Saint-Paul Hospital,
St-Rémy, as it appears today

RIGHT
Self-Portrait, 1889

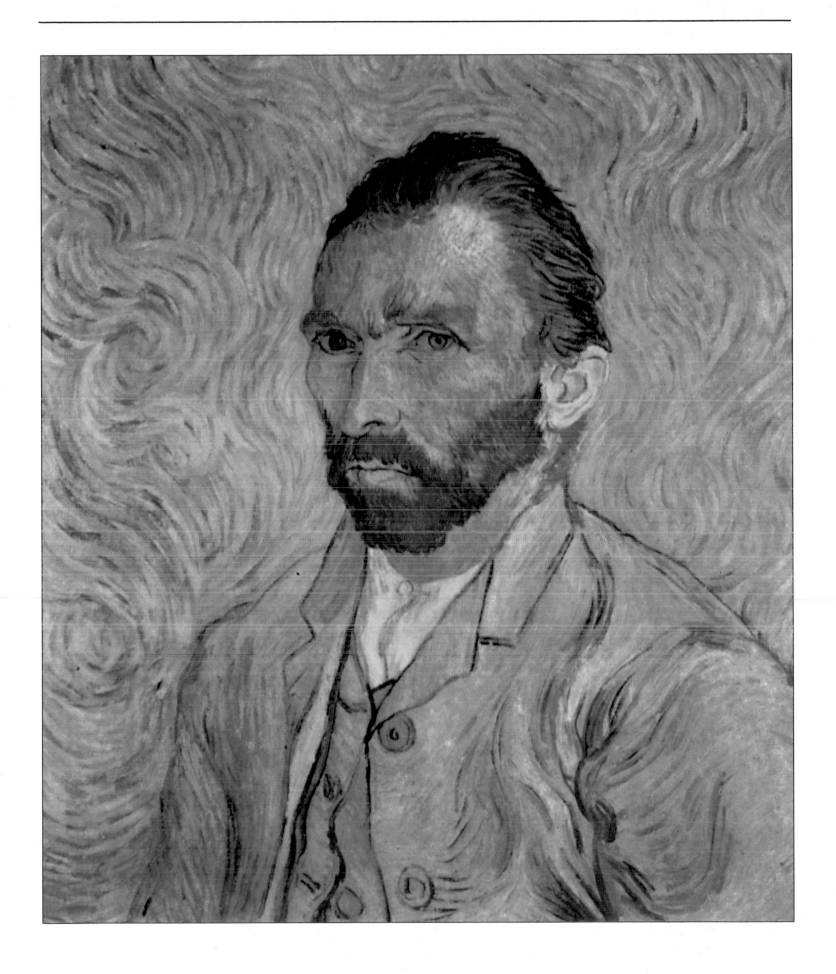

SAINT-REMY: *echoes of the Scriptures*

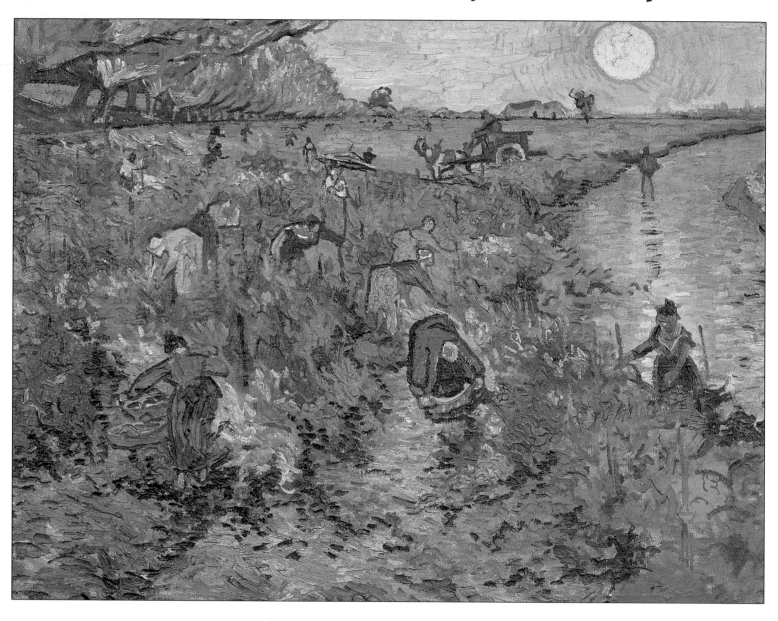

sentimentality. He was not merely copying these evocative works so much as translating them into another painterly language. He made over 20 such versions in six months. One highly-charged subject from this period, *At Eternity's Gate*, is a return to an earlier lithograph of his own, dating from his time at The Hague.

Meanwhile, he could feel pictures 'ripen in his head'. His landscapes began to include rocky or mountainous backgrounds, very different from the tranquil pastures of Arles. He told Bernard that this called for special treatment, veering towards abstraction. It was a question of according the sun and sky their full force and brilliance, of retaining the

aroma of wild thyme baked into the melancholy earth.

He had it in mind to make a study of a ravine: two masses of rock with a stream flowing in between and gradually disappearing into the surrounding terrain. To him a sense of anguish was as inherent in nature and natural forms as in Christ's feelings of loss and betrayal in the Garden of Gethsemane. Vincent was reacting against the inclusion of religious themes in works by some of his contemporaries, notably Gauguin and Bernard.

The one-time preacher and evangelist now saw no place for such imagery in contemporary art: it belonged, to his mind, in medieval

tapestries. In a disbelieving age it was totally out of place. In order to create an impression of sorrow or anguish there was no need to resort to religion or mythology. He defined his own work, compared with that of the Symbolists and their circle, as a kind of coarse realism. He was now taking each day as it came, finishing one work before beginning another.

Two short attacks, mild recurrences of his illness, re-awakened Vincent's ambitions to found a brotherhood of painters, even if there was no chance of restoring the brief experiment of Arles. He approached Gauguin, sounding him out on the idea of joining him at Pont-Aven. Perhaps, he suggested, it would be

worth a second attempt. Gauguin sent a diplomatic reply. Was Vincent sure he was quite cured? Might not his presence trigger another outburst like the drama of the cut ear? Perhaps he would be happier in Antwerp, where it was just as cheap to live as in Brittany. There were museums there, and a fine arts trade where he could expect to sell his work. He even suggested starting an art business in partnership with Vincent, though under his, Gauguin's name, of course.

Nothing came of these day-dreams. But events were to take an interesting turn. In an article devoted to Vincent's work, published in a

FAR LEFT
The Red Vineyard, 1888

LEFT
Olive Tree in the South of France

BELOW
Orchard in Blossom with
View of Arles, 1889

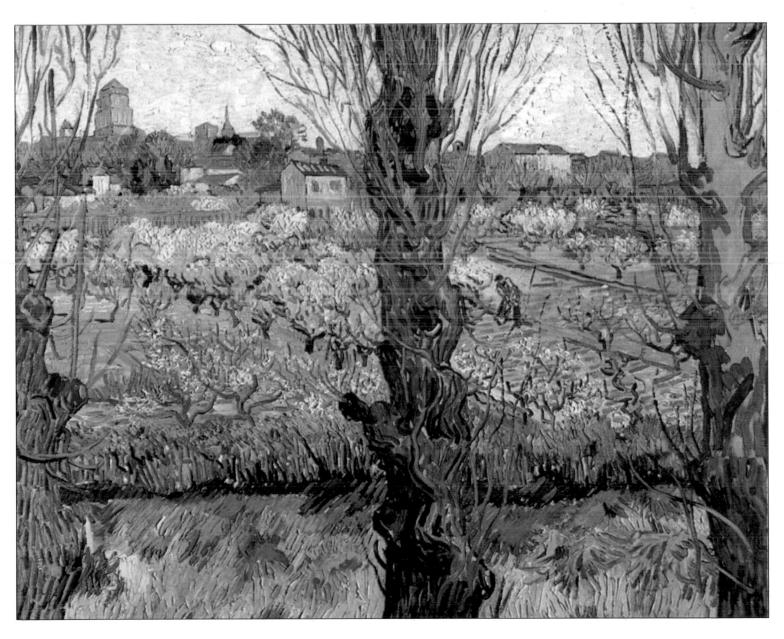

SAINT-REMY: *in the arms of friends*

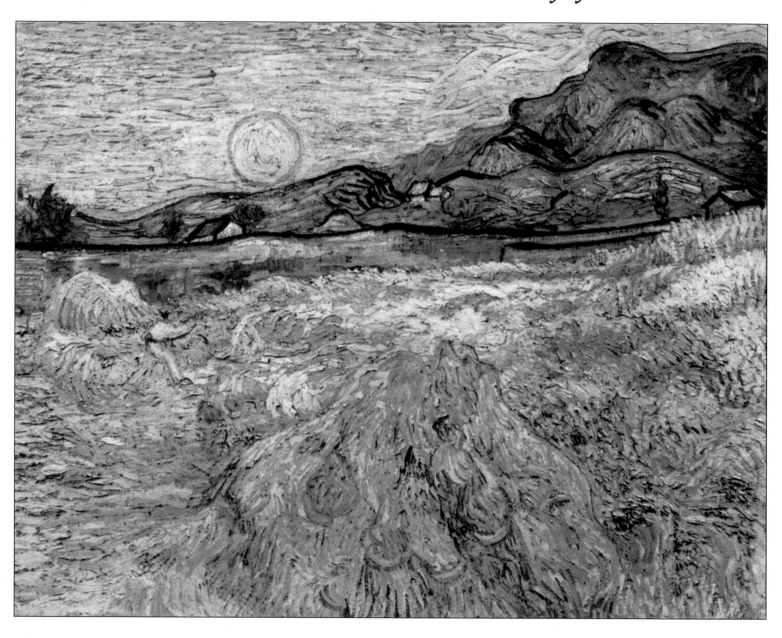

French journal in 1890 following an exhibition of Vincent's work in Brussels, the author, Albert Aurier, a self-styled Symbolist poet, recognized him as a modern master despite the disconcerting content of his work. The particular quality of Vincent's painting, he wrote, was its excess of strength, its highly-strung quality, its violence of expression. Aurier drew attention to Vincent's profound, almost child-like sincerity, his love of nature for its own sake, his simplification of forms, his 'insolence' in painting the sun face to face. The contrast between the violent extremes of Vincent's nature struck him as extraordinary; a fanatical

enemy of bourgeois values, capable of terrific feats but able to reveal the secrets of line and form. Van Gogh, he concluded, was convinced that art needed to be re-invented into newer, more powerful forms which the art world could understand. Aurier saw little chance of all this coming about. Public taste was still in its usual rut and it would be for future painters and admirers of his work to see that Vincent's views were at last accepted.

Vincent's reaction to this tribute was somewhat mixed. He was, however, gratified by the attention while maintaining that there were artists who were already starting to paint like himself. Why didn't Aurier

mention them? He humbly thought that he was still a long way from matching up to what had been written about him. In a long, sober letter to Aurier he recommended an obscure contemporary, Adolphe Monticelli, as more deserving of recognition than himself. He also made a plea for Gauguin, 'this alien whose bearing and gaze make you feel that a good picture should be the equivalent of a good deed.'

In more personal terms, the article had left him in a state of embarrassment. After all, he said, a painter was really 'just a cobbler'; though it would be a change for the better when the day came that painters

could begin to earn from sales of their pictures what they cost to produce. As for the Symbolists and their petty squabbles, he paid them no attention. He even ventured the thought that Aurier's article might prove the very catalyst he needed; encouraging him into realms far removed from reality; approaching a painting as one would a musical composition. In reaction to the article, he had painted a study of cypresses to enable him to clarify in his own mind what he felt about the artistic process. He could become so emotionally involved in a painting that he was liable to suffer from fainting spells.

In one important respect Aurier was beginning to prove right. Vincent's admirers were mostly to be found among the ranks of painters themselves. Since painters have little enough to spare in their efforts to keep afloat, as Vincent never tired of pointing out, they could hardly afford to collect paintings themselves. However, the purchaser of a recent work by Vincent, *The Red Vineyard*, at an exhibition in Brussels, turned out to be a painter, Anna Bock, a member of the XX, who paid 400 francs for it. Vincent, somewhat ungraciously, pointed out that this made no contribution to his fortunes, given the commissions and overheads involved in any transaction with a picture

LEFT
Enclosed Wheat Field with Reaper, 1889

BELOW
A Path Through the Ravine, 1889

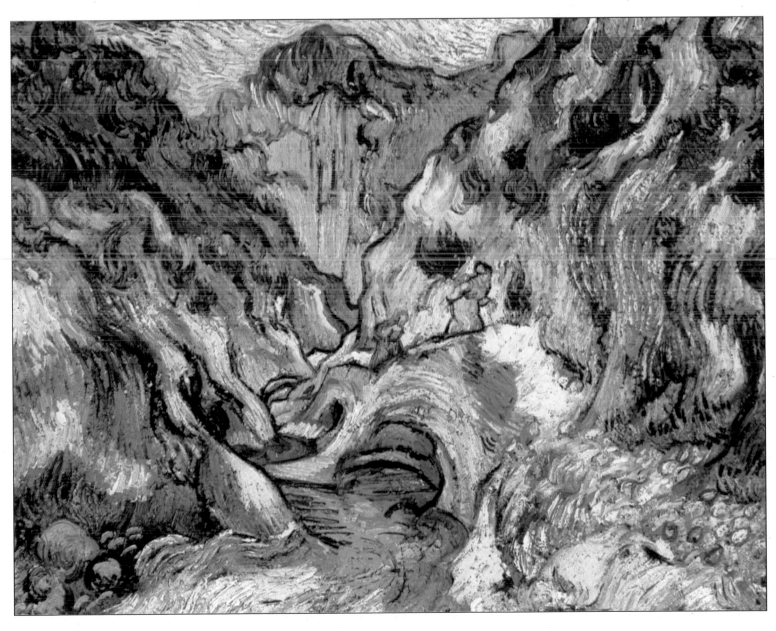

AUVERS: *a glint of light*

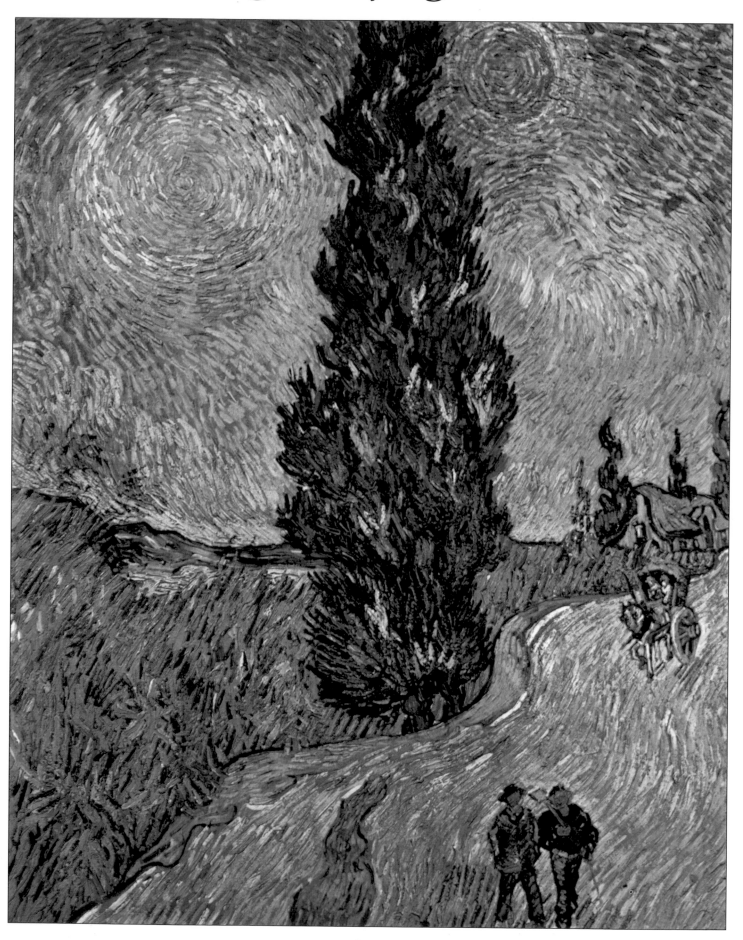

gallery.

For all his grumblings, Vincent was convinced that he was fit to leave hospital – he was bursting with ideas for paintings. After waiting for the opinion of his local doctor, which held matters up for a couple of weeks, he was at last free to go and caught the first train to Paris. Theo's wife, Johanna, went to meet him. She wrote later: 'I had expected a sick man, but here was a sturdy, broad-shouldered man with a healthy colour, a smile on his face, and a resolute appearance. My first thought was that he looked much stronger than Theo.' Soon Theo was taking his brother by the arm for a first glimpse of the infant Vincent. Johanna remembered that both men had tears in their eyes.

He stayed three days, studying the numerous paintings of his that hung on Theo's walls, and rummaging among the scores of others stored under beds, sofas and in cupboards. There were plenty of visitors who brought Parisian gossip into the house. Vincent started to feel claustrophobic as the hubbub of city life began to close around him, and began to yearn for the country. Towards the end of May 1890, he made his way to Auvers-sur-Oise and the house of Doctor Gachet, his last sanctuary of all.

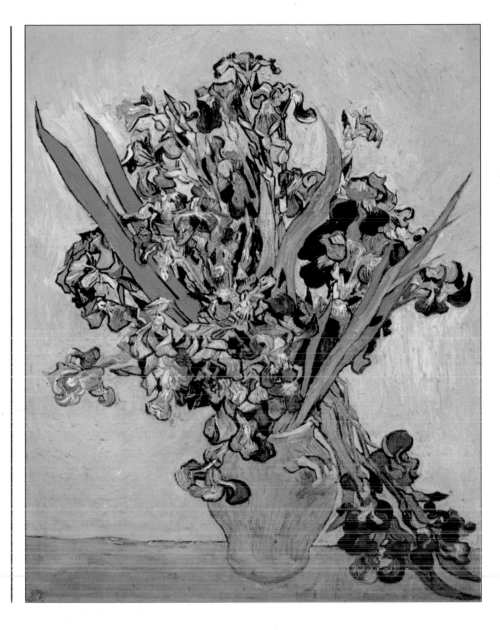

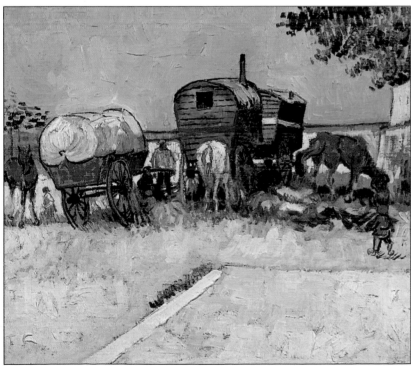

FAR LEFT
Road with Men Walking, Carriage, Cypress, Star and Crescent Moon, 1890

LEFT
Caravans: the Gipsy Encampment, 1888

ABOVE
Vase with Violet Irises Against a Yellow Background, 1890

AUVERS: *the close of the day*

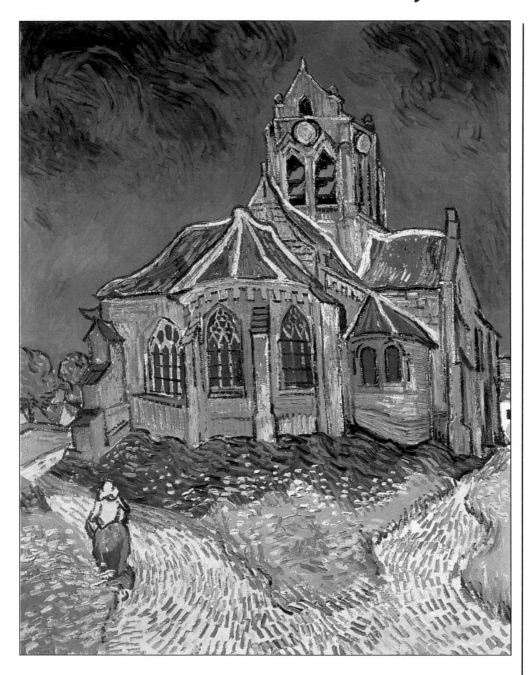

Gachet received him warmly, showed him his collection of Impressionist paintings, and suggested lodgings at the inn down the road. Vincent thought the daily charge there, six francs, was beyond his means. Instead, he booked himself into an attic room in a café-tabac opposite the town hall, for three francs fifty. He was attracted to the thatched roofs and tumbled cottages of the villagers, to which he added typically swirling skies. He painted Gachet's portrait and that of his daughter, Marguérite. His work-rate doubled and re-doubled: in seventy days he painted as many works and made more than thirty drawings, all from the surrounding countryside.

His one anxiety was that, as he saw it, the good Dr. Gachet seemed sicker than he, Vincent, did – an illusion that contradicted the scrupulous attention that Dr. Gachet was giving him at the time. He was also depressed, on a visit to Tanguy's, to find some of his own pictures mouldering at the back. A visit to see his little nephew raised his spirits. He showed him the surrounding animal life – cats, ducks, pigeons – while confessing that the infant did not seem to understand much of it as yet. There was more animal life in th Gachets' backyard, from turkeys and peacocks to sheep and a goat. These were contented days for Vincent, as he painted with a new intensity in the fields. The family's affectionate care drove all anxieties aside.

He set down his version of the village church, its curious appearance against a flat, deep blue sky, its windows of ultramarine, its church tower like the one in his home village of Nuenen years ago, except that in the southern light the colours which composed and surrounded the church looked richer to him and more expressive. The church, as he paints it, is a vivid, precarious place, with no apparent way in. Though it lies close to the home of the Gachets it offers no sanctuary. A women is shown bustling towards a distant cluster of red roofs. An ominous purple sky looms overhead. The vigorous earth seems on the point of heaving the whole place heavenwards, as a sort of whirlwind, in Vincent's own words, rises up from the earth, attacking both church and sky.

Suddenly the scene changed. The baby fell sick, and Theo and Jo became exhausted from nursing him all night. At the same time, Theo's position at the art gallery was threatened, facing him with the perilous alternative of setting up on his own. Theo's attentions to Vincent did not waver. He arranged meetings in Paris for his brother's benefit, including one with Albert Aurier, and a lunch with Toulouse-Lautrec, reviving memories of Montmartre in their student days. Vincent painted on tirelessly; thatched roofs, an old vine, pink chestnuts, marigolds, cypresses, white roses. Suddenly, in an abrupt change of mood, he left for the fields, carrying his painting gear, to return next morning as if nothing untoward had happened.

The final act has passed into legend; how, a couple of days later, Vincent was seen approaching the house from the fields, moving

strangely in long strides, his head tilted a little, rather as if he had been drinking. As he drew nearer he seemed to be clutching his stomach. He bade the family 'good evening' and climbed to his little room. Gachet followed, and asked what he had done. 'I have shot myself,' said Vincent. 'I only hope I haven't botched it.' Two days later he died. The gun, borrowed, was never seen again.

At no time was Vincent ever surrounded with such care and support

At his burial Doctor Gachet uttered a heart-broken farewell. He said of Vincent: 'He was an honest man and a great artist. He had only two ambitions, for mankind and for art. Art he loved above everything. And it ensures that he will live.' Albert Aurier, whose tribute in the *Mercure de France* had been the only one Vincent received in life, wrote of his obsessive passion for the sun and for the planet earth, 'that magnificent sunflower which tirelessly repeats an allegory of the Sun, God's creation, everything we feel and see. The beautiful Sun of midsummer, as Vincent called it, that beat down on his head, made him feel "just a little queer"...These forces infuse his art with longings that lie too deep for words.'

Piecing together the events and circumstances of Vincent's last days, his biographers have groped for reasons why he should have chosen to end his life at a moment when recognition at last seemed possible, when he was living among people who were devoted to him, and when the attentions of the skilled and sympathetic doctor, Paul Gachet, seemed to be containing the mental sickness that had laid him low in Arles. At no time was Vincent ever surrounded with such care and support. In the home of his brother

Theo, his wife Johanna and their little boy, Vincent Willem, he was sharing a life he had always longed for, loving and loved in return. These, though, were not circumstances likely to reconcile him to what other people regarded as a normal life. If anything, they could have had a directly opposite effect. He was aware of his own mettlesome nature and cannot have been indifferent to the impact of his behaviour. Whatever reassurance his release from the asylum might have given him, he accepted that there was something about him that kept others at a distance. However, there is a hint in one of his last letters that, despite Johanna's assurances, he feared that Theo's new responsibilities as a married man would mean the end of his regular financial support.

There are suggestions that Vincent, towards the end, nursed tender feelings for Gachet's teenage daughter, of whom he made a couple of oil sketches, one in the garden, the other at the piano. Picking over the scraps of later biographical evidence, one historian has suggested that it was Marguérite who felt a tenderness towards Vincent at that time, rather

than the other way round. It appears she never married and lived to the age of seventy-five.

The condition that brought about the death of Theo, six months after that of Vincent, a mental affliction akin to his, was also to claim one of their sisters in later years. However, Theo's son, the little Vincent, grew up to untroubled manhood and spent his life gathering his uncle's works together. Johanna set herself the task of transcribing all Vincent's letters, the vast majority written to Theo, and also made the first translation of them into English. The letters, and the family's store of Vincent's paintings, sketches and studies, form the priceless core of the Vincent van Gogh Foundation at Amsterdam.

LEFT
The Church at Auvers-sur-Oise, 1890

BELOW
Church at Auvers-sur-Oise as it appears today

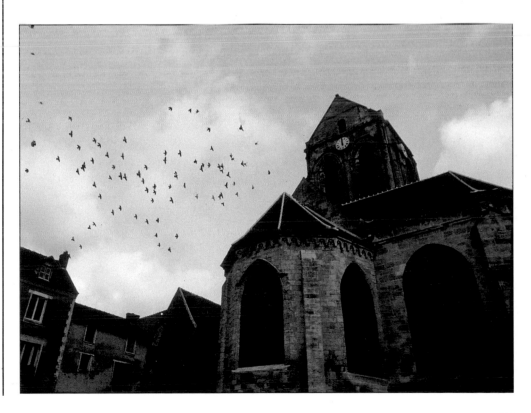

INDEX

Page numbers in italics refer to illustrations

Alyscamps, Les 58
Antwerp *19*, 29, 30, 34, 73
Arlésienne, L': Madame Ginoux with Books 64
Asnières 30, 36
At Eternity's Gate 72
Aurier, Albert 74-75, 78, 79
Auvers-sur-Oise *10*, *11*, *12*, 77
Avenue of Plane Trees Near Arles Station 49

Barbizon school of painters 16, 18
Basket with Lemons 58
Beach at Scheveningen in Calm Weather 18
Beach at Scheveningen in Stormy Weather, The 20
Bernard, Emile 9, 31, 33, 35, 36, 45, 48, 62, 72
Blossoming Almond Branch in a Glass 55
Boats with Men Unloading Sand 11
Borinage, The 7, 12, 14, 19
Boussod & Valadon 6, 9
Bowl of Flowers 36-37
Bowl with Zinnias 35
Brabant *12*, 12, 19
Brussels 6, 7, 16, 22, 74, 75

Café Terrace on the Place du Forum, Arles, at Night, The 50, 61
Caravans: the Gipsy Encampment 77
Cézanne, Paul 33, 41, 69
Châtou 30, 36
Chavannes, Puvis de 36
Church at Auvers-sur-Oise, The 78
Clichy, Boulevard de *30*, 31, 35
Cormon's Academy 9, 30, 31, 33, 35, 36
Corot, Jean-Baptiste Camille 6, 24, 38
Cottage with Women Digging 27
Couples in the Voyer d'Argenson Park at Asnières 42-43
Cradle, The 19
Crau with Peach Trees in Blossom, La 56-57
Cuesmes 15, *19*

Dance Hall in Arles, The 53
Degas, Edgar 38
Delacroix, Eugène 10, 24, 30, 38, 70
Dordrecht 6, 14, 19
Drawbridge with Carriage 51
Drenthe 8, 12, *19*, 19, 24, 25
Durand-Ruel, Paul 33

Eindhoven *19*, 29
Enclosed Wheat Field with Reaper 74
Etten 6, 7, 16, *19*, 19

Farms 24
Fishing in the Spring, Pont de Clichy 45

Gachet, Marguérite 78, 79
Gachet, Dr. Paul 11, 77, 78, 79
Gardens of Montmartre, The 47
Gauguin, Paul 9, 10, 35, 41, 45, 46, 50, 57, 58, 59, 62, 69, 72, 73, 74
Girl in the Street, A 8
Goupil's 6, 13, 33, 50

Hague, The 6, 8, 9, 12, 14, *19*, 22, 25, 72
Helvoirt 6, *19*
Hoornik, Clasina *see under* Sien

Irises 69
Isleworth 6, *12*, 13

Italian Woman, The (Agostina Segatori) 46

Japonaiserie: Bridge in the Rain 34, *38*
 Courtesan, The 34
 Flowering Plum Tree 34, *38*
Joinville 30, 36

Kee 7, 8, 16, 19

Ladies of Arles (Memory of a Garden at Etten) 52-53
Landscape with Church and Farms 22-23
Lane with Poplars 26-27, *27*
Lepic, rue *30*, 35
London 6, 8, 12, 13, 14, 22, 23
Louvre, The 6, 12, *30*, 30, 31, 35
Loyer family 6, 15

Maison Jaune, La *see under* Yellow House, The
Mauve, Anton 8, 9, 17, 18, 21, 28
Men and Women Miners Going to Work 15
Millet, Jean-François 7, 10, 16, 18, 24, 27, 31, 50, 70
Milliet, Paul-Eugène 50
Monet, Claude 33, 34, 48
Monticelli, Adolphe 38, 74
Montmartre: Quarry 38
Moulin de la Galette, Le, 1886 35, 36, *38*
Moulin de la Galette, Le, 1887 9

Night Café in the Place Lamartine in Arles 10, 51, 62-63
Nuenen 8, *19*, 25, 27, 29, 78

Opwetten *19*, 25
Orchard in Blossom with View of Arles 69, 73

Pair of Shoes, A 34
Path Through the Ravine, A 75
Paul Gauguin's Armchair 65
Peasant Woman Digging 28
Peat Boat with Two Figures 25
Père Tanguy 39
Petersham 16
Pigalle, Place *30*, 30, 31
Pine Tree with Figure in the Garden of Saint-Paul Hospital, Saint Rémy 70
Pissarro, Camille 33, 35
Poet's Garden, The 57
Pointillism 9, 35, 36
Pont-Aven 9, 58, 72
Portrait of a Woman with Red Ribbon 28
Potato Eaters, The 9, 28, *29*, 35, 36

Ramsgate *12*, 13
Red Vineyard, The 11, 69, *72*, 75
Rembrandt Van Rijn 6, 9, 13, 27, 69, 70
Renoir, Pierre Auguste 33, 48
Restaurant de la Sirène at Asnières 40-41
Rey, Dr. Félix 10, 65
Road with Men Walking, Carriage, Cypress, Star and Crescent Moon 70, *76*
Roulin, Joséph 10
Rubens, Peter Paul 30

Saint-Paul Hospital 70
Saint-Rémy-de-Provence 10, *49*, 65, 66, 69, 70
Saintes-Maries-de-la-Mer 10, *49*, 50
Salon (Paris) 16, 36
Scheveningen 19
Seascape at Saintes-Maries 59

Segatori, Agostina 38
Self-Portrait, 1887 48
Self-Portrait, 1887/88 10
Self-Portrait, 1889 71
Self-Portrait with Bandaged Ear 67
Seurat, Georges 9, 35, 36
Sien 8, *19*, *21*, 22, 24, 25
Signac, Paul 9, 35, 38, 41
Sisley, Alfred 33
Skull with Burning Cigarette 31
Sorrow 21, *22*
Sower, The 17
Spectators in the Arena at Arles 53
Starry Night 62, 68-69
Starry Night over the Rhône 4
Still Life: Blue Enamel Coffee Pot, Earthenware and Fruit 50
Still Life with Coffee Pot 47
Sunflower series 10, 57, 69

Tambourin, Le 9, 38
Tanguy, Julien 'Père' 9, 34, 78
Thatched Cottages by a Hill, Auvers-sur-Oise 4
Toulouse-Lautrec, Henri de 9, 33, 35, 36, 42, 48, 78
Trees in the Garden of Saint-Paul Hospital 4
Trinquetaille Bridge, The 60
Turnham Green 16
Two Cut Sunflowers 66-67
Two Peasant Women, Digging 27

Valadon, Suzanne 36
Van Gogh, Pastor *12*, 12, 16
Van Gogh, Theo 7, 10, *10*, 10, 11, *12*, 12, 13, 22, 25, 27, 29, 30, 31, 33, 34, 35, 38, 41, 45, 47, 48, 50, 51, 55, 57, 58, 62, 65, 66, 69, 77, 78, 79
Vase with Poppies, Cornflowers, Peonies and Chrysanthemums 33
Vase with Violet Irises Against a Yellow Background 77
View from Vincent's Window 32
Vincent's Bedroom in Arles 54-55
Vincent's Chair with His Pipe 65
Vingt, Les (XX) 69, 75
Vos-Stricker, Cornelia *see under* Kee

Weaver Facing Right 7 (Detail), 14
Wheat Field with a Lark 44-45
Wheat Field with Reaper at Sunrise 69
Willows at Sunset 18
Women Miners 14

Yellow House, The 10, 50, 57, 65

Zevenbergen 13, 19
Zundert 6, 19
Zweeloo *19*, 24